the photographer's
guide to the

Blue Ridge Parkway

Where to Find Perfect Shots and How to Take Them

Jim Hargan

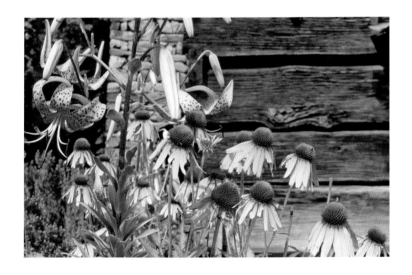

THE COUNTRYMAN PRESS
WOODSTOCK, VERMONT

The Photographer's Guide to the Blue Ridge Parkway
ISBN: 978-0-88150-873-4

Interior photographs by the author unless otherwise specified
Maps by Paul Woodward, © The Countryman Press
Book design and composition by S. E. Livingston

Published by The Countryman Press,
P.O. Box 748, Woodstock, VT 05091

Distributed by W. W. Norton & Company, Inc.,
500 Fifth Avenue, New York, NY 10110

Printed in China

10 9 8 7 6 5 4 3 2 1

Title Page: Native wildflowers at the Oconaluftee Mountain Farm Museum
Right: Waterrock Knob Trail

For my dad—the first Hargan photographer

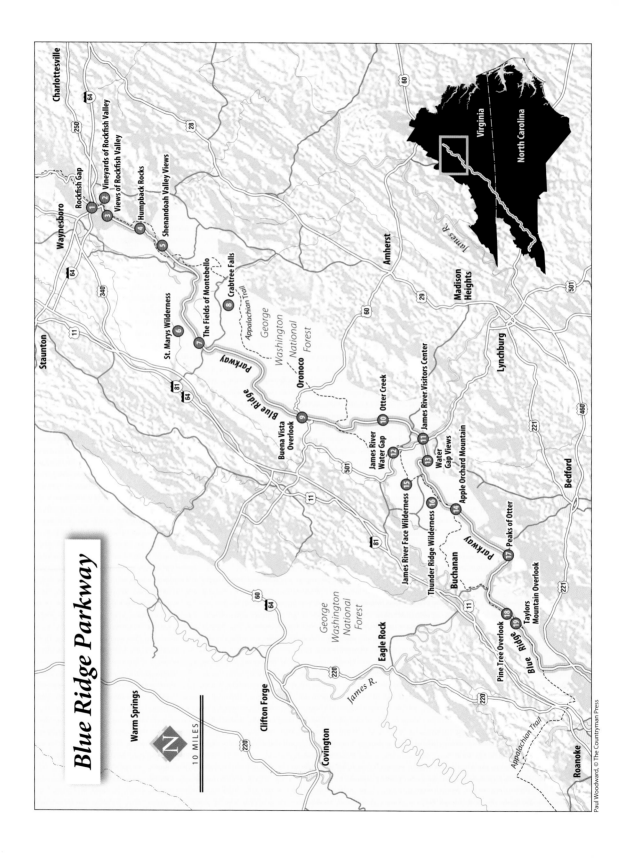

Blue Ridge Parkway

Charlottesville

Waynesboro

Staunton

Warm Springs

Clifton Forge

Covington

Eagle Rock

Buchanan

Roanoke

Bedford

Lynchburg

Madison Heights

Amherst

Oronoco

Virginia

North Carolina

George Washington National Forest

James R.

James R.

Appalachian Trail

Blue Ridge Parkway

Blue Ridge

10 MILES

N

1 Rockfish Gap
2 Vineyards of Rockfish Valley
3 Views of Rockfish Valley
4 Humpback Rocks
5 Shenandoah Valley Views
6 St. Marys Wilderness
7 The Fields of Montebello
8 Crabtree Falls
9 Buena Vista Overlook
10 Otter Creek
11 James River Visitors Center
12 James River Water Gap
13 Water Gap Views
14 Apple Orchard Mountain
15 James River Face Wilderness
16 Thunder Ridge Wilderness
17 Peaks of Otter
18 Pine Tree Overlook
19 Taylors Mountain Overlook

Paul Woodward, © The Countryman Press

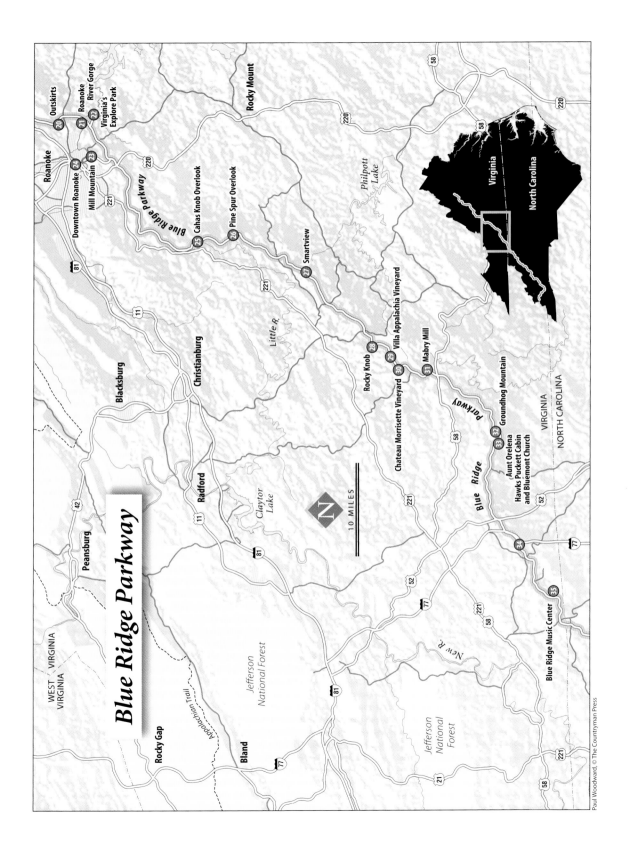

Blue Ridge Parkway

WEST VIRGINIA

Rocky Gap

Bland

Jefferson National Forest

Peansburg

Appalachian Trail

Blacksburg

Christianburg

Radford

Claytor Lake

Jefferson National Forest

New R.

Roanoke

Downtown Roanoke 24

Mill Mountain 23

Blue Ridge Parkway

Cahas Knob Overlook 25

Pine Spur Overlook 26

Smartview 27

Little R.

Outskirts 20

Roanoke River Gorge 21

Virginia's Explore Park 22

Rocky Mount

Philpott Lake

Rocky Knob 28

Villa Appalachia Vineyard 29

Chateau Morrisette Vineyard 30

Mabry Mill 31

Parkway

Groundhog Mountain 32

33 Aunt Orelena Hawks Puckett Cabin and Bluemont Church

Blue Ridge

VIRGINIA

NORTH CAROLINA

34

35 Blue Ridge Music Center

N

10 MILES

VIRGINIA

NORTH CAROLINA

Paul Woodward, © The Countryman Press

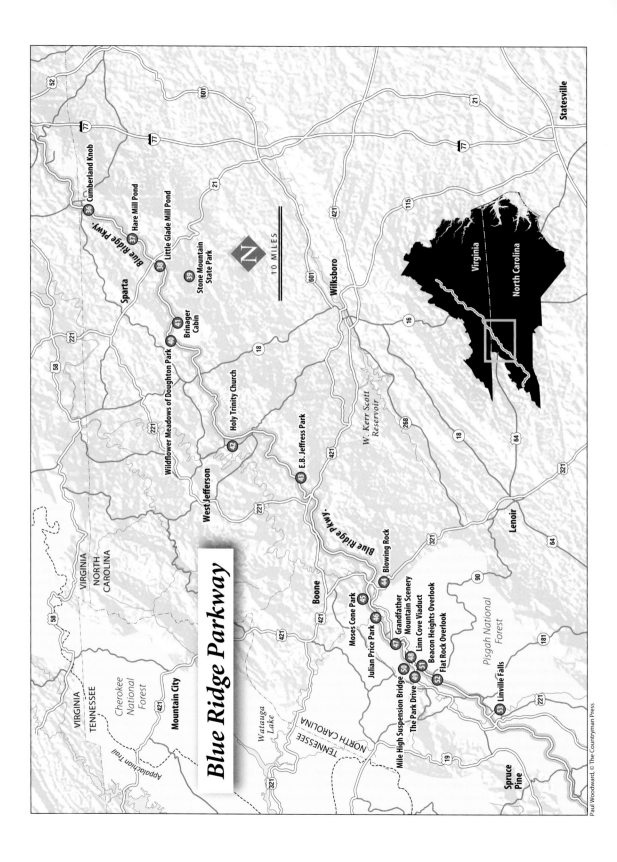

Blue Ridge Parkway

Paul Woodward, © The Countryman Press

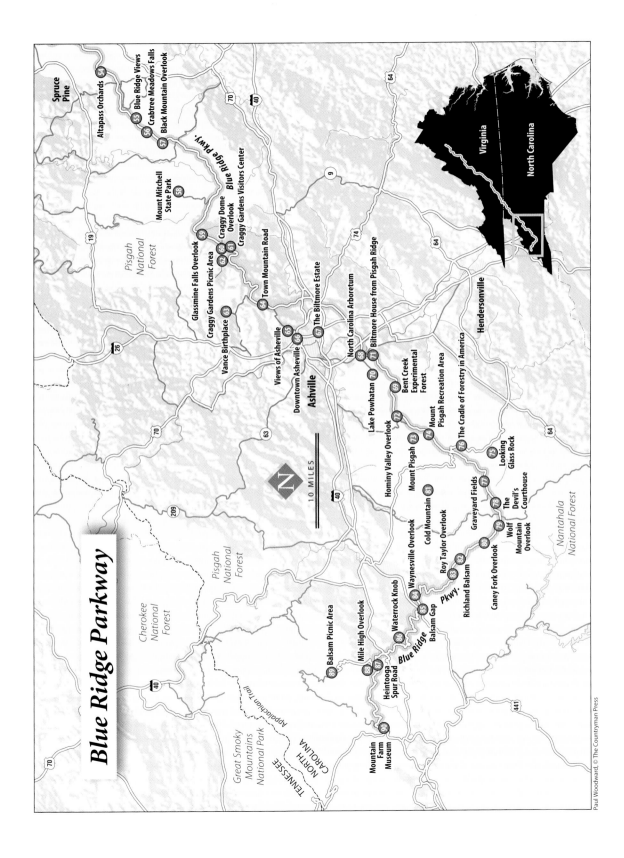

Blue Ridge Parkway

Spruce Pine

Altapass Orchards 54
Blue Ridge Views 55
Crabtree Meadows Falls 56
Black Mountain Overlook 57

Pisgah National Forest

Mount Mitchell State Park 58

Blue Ridge Pkwy.

Craggy Dome Overlook
Craggy Gardens Visitors Center
Glassmine Falls Overlook 59
Craggy Gardens Picnic Area 60 61
Town Mountain Road 62
Vance Birthplace 64
Views of Asheville 65
Downtown Asheville 66
The Biltmore Estate 67

North Carolina Arboretum
Biltmore House from Pisgah Ridge

Asheville

Lake Powhatan 68 71
Bent Creek Experimental Forest 69
Mount Pisgah Recreation Area 70
The Cradle of Forestry in America 72
Hominy Valley Overlook 73
Mount Pisgah 74
Looking Glass Rock 75 76

Hendersonville

Mount Pisgah 81
Cold Mountain
Graveyard Fields
The Devil's Courthouse 77 78
Waynesville Overlook
Roy Taylor Overlook 79 80
Wolf Mountain Overlook
Richland Balsam 82
Caney Fork Overlook 83

Balsam Picnic Area 89
Mile High Overlook 88
Waterrock Knob 86
Balsam Gap 85
84

Blue Ridge Pkwy.

Heintooga Spur Road
Blue Ridge
Balsam Gap

Great Smoky Mountains National Park
Appalachian Trail
TENNESSEE
NORTH CAROLINA
Cherokee National Forest
Pisgah National Forest
Nantahala National Forest

Mountain Farm Museum 90

N
10 MILES

Virginia
North Carolina

Paul Woodward, © The Countryman Press

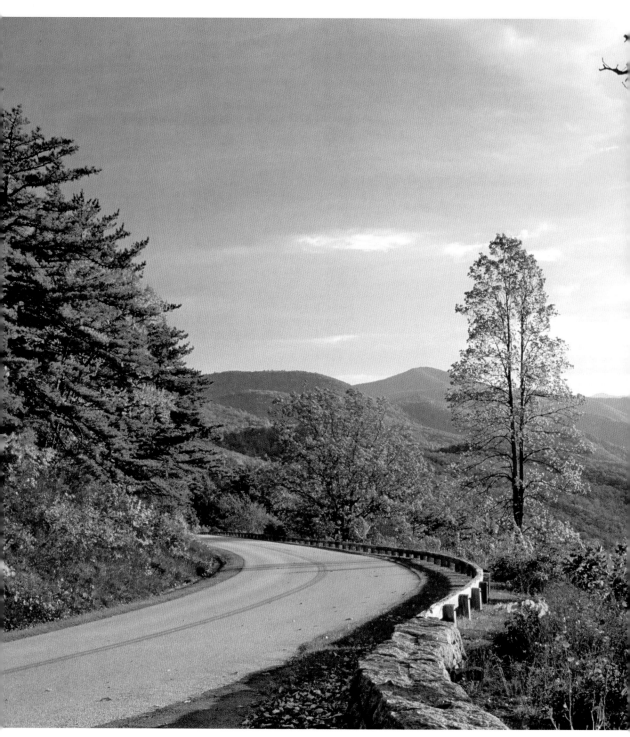

View of Shenandoah Valley near Greenstone Overlook

Contents

Introduction

Imagine a landscaped garden drive that's nearly 500 miles long. Imagine that the gardeners have designed this drive so artfully that you seem to be viewing natural, unaltered beauty—a beauty that varies continuously, from traditional farmlands to rocky wilderness to rivers and lakes and wildflower meadows. Add to this a route that passes among the tallest mountains in the East, with a valley floor as much as 0.75 miles beneath your feet. It seems impossible, but it's not. It's the Blue Ridge Parkway, and (understandably enough) it's the most popular destination in America's national park system.

The Blue Ridge Parkway starts at the southern edge of Virginia's Shenandoah National Park, less than three hours from Washington, D.C., at a concrete marker that declares it Milepost 0. From there it ambles along the crest of the Blue Ridge through the mountains of rural Virginia and North Carolina, every mile marked with another concrete post, until it finally moseys into the Great Smoky Mountains National Park at Milepost 469. Follow it and you will see no billboards, pass no houses or businesses fronting on the roadway, drive through no towns. Indeed, you will come across not so much as a stop sign—just one long, continuous experience. You will chance upon countless views of deep mountain valleys and quaint mountain farms framed by stone walls, split-rail fences, and, if you time it right, bright purple rhododendrons. You will also come across 20 park-like areas whose attractions range from pioneer farms to scenic vistas. In these parks you will have a chance to stroll to waterfalls and along millponds, to visit log cabins and gristmills, to listen to mountain music and see mountain crafters at work.

This book will lead you to the most beauti-

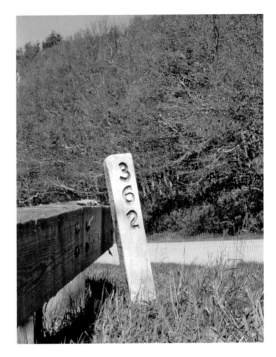

Blue Ridge Parkway milepost

ful and photogenic spots on the Blue Ridge Parkway, discuss the features that make them visually rewarding, and give you hints on how best to capture them in your photographs. However, you don't have to be a serious photographer—or even a photographer at all—to enjoy this book. You need only be a lover of nature, and a person who appreciates the interesting, the unusual, and the spectacular. If in addition you happen to be serious about your photography, you'll get a bonus: this book will lead you to the best places to aim your lens, and provide guidance on seasons and times of day as well as subjects calling out to be photographed. You'll also find warnings about potential pitfalls, and enough description to help you decide what to avoid as well as what to visit.

The parkway as a landscaped drive: Glassmine Falls Overlook, MP 361

How to Use This Book

The Blue Ridge Parkway is a two-lane highway managed by the U.S. National Park Service, 469.1 miles long with mileposts every mile, numbered north to south. These mileposts are low pillars of rough concrete with the number deeply incised and painted blue. All photo sites in this book refer to these mileposts (or MPs); as an example, Milepost 72 means "at or near Milepost 72," while Milepost 72.6 means "six-tenths of a mile past Milepost 72."

And what makes a photo site? It could be a view, or a log cabin, or wildflowers, or a lush forest—anything that frames up nicely in a viewfinder. But each of the sites included here is a place worth seeing, whether you've got your camera with you or not.

This book highlights two special types of sites. The first type is a major recreation area along the parkway, wide areas with a concentration of things to see and do; these are labeled "String of Pearls," a description used by the parkway's original designer back in the

1930s. The second is a feature just off the parkway, easily reached and worth the trip; these are labeled "Off the Parkway," and the text gives their distance from the nearest parkway milepost.

In using this book you'll need to make some purely practical decisions. If you're planning to drive the entire parkway in one trip, your first and most important decision will be how much time you're going to devote to the journey. Given that the speed limit on the parkway is 45 miles an hour, you might think you could complete the drive, stem to stern, in ten hours and 25 minutes. Well, forget it. First of all, unless you are an experienced mountain driver, you'll be going 35 rather than 45 mph, stretching the travel time out to 13 hours and 20 minutes, plus restroom and food breaks. Second, you are going to catch up with someone driving even slower than that and not be able to pass; the parkway is intentionally designed in broad sweeps to improve visual interest, and there are few places straight enough to allow for passing. Third—weren't you going to stop and take some pictures?

If you have limited time, you can make the drive in two days, with an overnight stop at the parkway's full-service Doughton Park (MP 241.1), at almost exactly the halfway point. It'll be a long two days, however; expect the actual physical driving to consume seven hours each day, leaving only a scant two or three hours for photography and meal and restroom breaks. A two-nighter is better, giving you the chance to actually check out a variety of this book's listings. The parkway does not break evenly into thirds; I suggest a first night at Roanoke (MP 112.2) and a second night at Blowing Rock (MP 291.9).

As lovely as the parkway is, you will need to exit occasionally to find places to eat, get gas, use the restroom, and sleep. Its original designer intended for you to do all of these things without leaving the parkway, but that goal has been slipping for years. At one point or another, you will have to exit. This book will indicate the best exits for such pit stops.

Finally, you must decide on your direction. Again, the Blue Ridge Parkway is mileposted from north to south—an arbitrary choice probably due to the roadway's proximity to Washington, D.C., on its northern end. Arbitrary or not, it is the convention, and this book follows it. Not only are all sites given north to south, but all directions are given as for someone traveling in that direction. Movement in the direction of higher milepost numbers is always "forward" or "front" or "up," and movement in the opposite direction is always "behind" or "backward" or "back."

But is this actually the best direction of travel? It can be argued that the parkway's designer organized the roadway, its scenic vistas, and its interpretive areas to form a north-to-south progression, so that traveling in that direction gives you an experience closer to the designer's original intent. That may be so, but it also puts the sun in your eyes. And going south to north gives you an added advantage: the mileposts tell you how far you are from the end. That said, each direction will yield views, and therefore photographs, substantially different from the other.

More Parkway Information

Detailed advice on dining and lodging along the parkway can be found in *The Shenandoah Valley and the Mountains of the Virginias: An Explorer's Guide,* which covers the parkway in Virginia and mountains to the west of the Blue Ridge, and *The Blue Ridge and Smoky Mountains: An Explorer's Guide,* with chapters on the Great Smoky Mountains National Park and surrounding mountains. Both, as chance would have it, are written by me and published by The Countryman Press.

Isolating and framing a beautiful view: Flat Rock Overlook, MP 308

How I Photograph the Blue Ridge Parkway

Think of photography as storytelling. Before you look through your viewfinder, ask yourself, "What story do I want to tell?" Resist letting a sudden spark of inspiration lead you to click like mad in all directions. A certain deliberateness at this point will improve your results tremendously. What idea do you want to communicate? It may be, "Boy, is this beautiful!" Okay, so stop and consider: what's beautiful about it? Isolate the feature—then tell the story.

Just as a written story has a beginning, a middle, and an end, a photographic story has a foreground, a middle ground, and a background. Place your main feature within the camera's rectangular frame, then organize a foreground and background to tell the story. Position wildflowers in the foreground of a vista to tell the story of a lovely grassy area, for example, or a tree trunk in the foreground of a waterfall to tell the story of a wooded view. And don't think the major subject has to be placed in the center. Locate a major subject that happens to be in the background in the upper-right two-thirds of the frame, and balance it with a foreground object in the lower left third of the frame. Once you have your story roughed out, it's time to experiment—film is cheap, and digital exposures are free.

One way of gaining this deliberateness, this attentiveness to storytelling, is with a tripod. We think of a tripod as a way of increasing resolution by suppressing camera motion, but it is more than that. By fixing the camera at a single, firm spot, you can contemplate the elements of the image at your leisure, think about the composition of your story, make fine adjustments. Freed from the Tyranny of the Shaking Hand, you can stop your lens down as far as it goes, then adjust your back-to-front focus ("depth of field") exactly the way you want. You might then try fitting a polarizing filter over your lens, quadrupling the time your shutter is open but intensifying your colors.

When you are telling photographic stories about the Blue Ridge, certain themes suggest themselves. The story of **mountain grandeur** may well be the one you wish to explore in most depth—and I confess to being a bit of a view addict myself. The parkway's grandeur tale, however, will be different from the one you would tell about the Colorado Rockies, for example, or England's Lake District. Even at its highest points, the Blue Ridge is covered with trees, giving it a softer, more graceful appearance than those famously rugged ranges, even in the (frequent) places where the Blue Ridge is just as steep. The parkway's story of mountain grandeur is best told within the context of this great forest.

Of course **the forest** is, of itself, a major story. The trees are huge and beautiful; the understory is seasonally colorful with the blossoms of dogwood, azalea, silver bell, rhododendron, and mountain laurel; and the forest floor is studded with moss, lichens, and rocks. This is one of the most varied forests in the world, with more tree species than all of temperate Europe, and as many as 30 species in a single acre.

While many photographers are content to tell the story of nature along the Blue Ridge Parkway, others of us are not satisfied until we weave within it **the human story**. The parkway itself presents us with two wildly different themes. The first is **pioneer history**, preserved by the park service in a series of log cabins, farmsteads, and fields, and intentionally presented as a story of people in harmony with

their surroundings. Do you accept this story? Or will you push to find another, perhaps less romantic, one? The second human story is that of **the parkway itself**, a work of art by one of America's most notable landscape designers, Stanley Abbott. Look for design features great and small, from magnificent bridges to the intricate stonework of Italian masons. And contemplate the views, both wide and intimate, as an intentional framing of the region's natural beauty.

Blue Ridge Specialties

The Mountains

The Blue Ridge is a very old, very rough linear mountain range that runs from Dillsburg, Pennsylvania, to Chatsworth, Georgia, with the parkway coterminous with its central half. The Blue Ridge is not the only linear mountain range in the East, but, at 840 miles, it's the longest. It's not its length, however, that distinguishes it from other mountains in the Appalachians, of which it is a part. The Blue Ridge has a distinctive geology, and this gives it a look that's unique on the globe. As this book is about appreciating that unique look and capturing it on film, let's start by exploring it a bit.

To get a handle on what distinguishes the Blue Ridge, imagine flying over the range from east to west. Before you reach it you'll be passing over rolling farmland with elevations that run from 500 to 800 feet. This ends abruptly at a steep-sided mountain, covered in trees with an occasional gray cliff, extending without a break as far as you can see—the Blue Ridge, a name found on the oldest colonial maps. It rises from 1,000 to 2,000 feet above the valleys below, pretty much straight up. Unlike the East's other linear mountains, it has a lumpy crest, with distinctive peaks and gaps, and its rock, where exposed, is nearly always a gray mass with no bedding. Along the section

of the Blue Ridge followed by the parkway, only Virginia's James River manages to pierce it, cutting a deep and treacherous gorge in the process.

What comes next depends on where you are; the parkway passes through three sections, each distinguished by its western side. First, at the parkway's northern end, the Blue Ridge is a simple backbone of super-hardened old rock; the James River has carved away the younger, softer rock that once covered its western slopes. Then, south of Roanoke, comes a section where there is no western drop-off at all, as the local streams are not strong enough to wash away the overburden. Finally, at the North Carolina state line, ancient fault lines push up a huge oval chunk of the Blue Ridge, forming an island in the sky that's 30 to 50 miles wide and 230 miles long. Here many peaks are over a mile high and 40 top 6,000 feet—the tallest mountains in the East.

As a photographer, what should you look for along this strange geographic formation? What features separate the Blue Ridge from every other mountain range in the world? Here are a few:

- A mad jumble of peaks made of masses of gray bedrock, rather than orderly ridgelines that show sedimentary bedding
- Convex cliffs (called "rocky balds") that start out gently sloping, become more rounded, and then gradually plunge into a sheer drop
- Small bowl-like valleys perched high along the ridge crest
- Rounded, humped peaks, occasionally covered in grassland rather than trees (called "grassy balds," a relic of 19th-century transhumance)
- Ridge crests that sometimes become a razor's edge of exposed rock
- Waterfalls at high elevations

• A tall, steep, unbroken scarp face on the east and, south of Roanoke and in parts of North Carolina, a much gentler (or even nonexistent) slope on the west

The Parkway

In the 1920s the National Park Service (NPS) decided to establish two new parks in the South's Blue Ridge region: **Shenandoah National Park** just west of Washington, D.C., and the **Great Smoky Mountains National Park** along the North Carolina–Tennessee border. By 1933 both parks were becoming a reality, and regional tourism promoters suggested that the NPS could increase their success by connecting them with a highway. The park service thought this was a great idea, and convinced the Roosevelt administration that the Park-to-Park Highway (as it was then called) would be an effective public works project in a desperately poor section of the country. After some debate, the park service chose a route along the Blue Ridge as being particularly impoverished, even by Great Depression standards.

Up till then everyone assumed that the new highway would be just that—an ordinary, modern highway. In 1935, however, the NPS hired landscape architect Stanley Abbott to design it, and Abbott sold the park service on a bold new idea: a great linear museum of Appalachian beauty and culture, designed to fade into nature using landscaping principles developed by Frederick Law Olmsted (of Central Park fame). Abbott stated that the parkway should "lie easily on the ground, blend harmoniously with the topography, and appear as if it had grown out of the soil." Abbott loved both the people and the scenery he found along the Blue Ridge route, and began transforming the Park-to-Park Highway into the Blue Ridge Parkway.

Abbott started by making some major changes to the parkway's specifications. He ex-

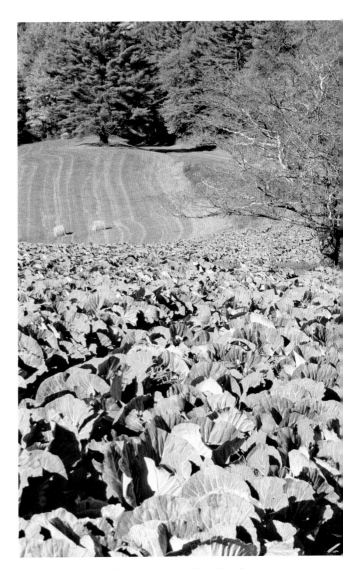

Cabbages grow in the parkway's wide right-of-way near Pinnacles of Dan Gap, MP 183

panded the right-of-way from that of a normal road to 1,000 feet, so that he could fully control its appearance. He converted it to a limited-access road, with expressway-style interchanges at major highways and nearly no access to back roads. He prohibited driveway entrances, store frontages, private signs, tractor crossings, and even mailboxes. Abbott did not

allow the parkway to become an improved replacement for local roads; instead, the local dirt roads continued alongside the parkway, and locals were ordered to use these for their tractors and school buses. Abbott made it stick; this was going to be a recreational road, and nothing would be allowed to detract from its use in this way.

Abbot laid out the landscaping so that every prospect would be fresh and exciting, and every turn would reveal something new. He intended to alternate types of scenery, making sure that the experience would never degenerate into a series of views. As part of this he set about creating a series of recreational opportunities, wide spots in the road where visitors could park their cars, get out, and do something. He described this design as a **String of Pearls**.

Abbott meant to complement his visual design with opportunities to enjoy mountain culture and history, turning the parkway into something like a linear cultural museum. Alas, Abbott was out of his element here, as were his fellow rangers (foresters and naturalists, not historians) within the NPS. Abbott and the rangers approached Appalachian culture through stereotypes of pioneer self-sufficiency, believing that they were seeing an early frontier culture surviving into modern times rather than just really poor and isolated folk. Not just Abbott, but the entire NPS in the East, remained devoted to this myth for decades. They destroyed vernacular buildings that happened to be built of sawn lumber under the ignorant impression that these were "modern," and mixed-and-matched log cabins of different periods to create "typical" farms. Keep an eye open for the quaintly picturesque "pioneer" landscapes along the parkway; they say as much about the preconceptions of 20th-century planners as they do about the people of the Blue Ridge.

Working with Blue Ridge Seasons

Spring

Spring proceeds with painful slowness along the Blue Ridge. At the lowest elevations spring starts at the normal time, with daffodils appearing the last week of March and the trees starting to leaf by early April. Up at the high points of Mount Mitchell and Richland Balsam, spring is still six weeks away. Your photography of mountain vistas will be affected—perhaps "spoiled" is the better word—by the gray, leafless forests stretching along the upper altitudes. On the other hand, your chances for good wildflower photography are wonderful. With five climate zones and one of the richest temperate forests in the world, the Blue Ridge enjoys a variety in its flora that is unmatched. Even better, you can adjust the blooming season to match your schedule, moving uphill for flowers that have normally bloomed by the time you arrive, and downhill for late bloomers. The parkway's wide shoulders bring sun into the forest edge, encouraging a joyous profusion of meadow and glade flowers.

The flowering understory trees are the showiest and most easily photographed of the wildflowers. Dogwoods appear early, just as the bulk of the surrounding trees burst into leaf, although exotic garden varieties may bloom earlier or later in landscaped areas. The deep magenta Catawba rhododendron appears after the dogwoods have faded; bushes within the forest will have isolated blooms, but Catawbas that receive direct sun will be densely covered in vibrant blossoms. The rhododendron bloom moves up the mountains, climaxing in early summer with stunning displays on the high grassy balds. Flame azaleas, bright orange flowers on tall, spindly bushes, appear at the same time as the Catawba rhododendrons.

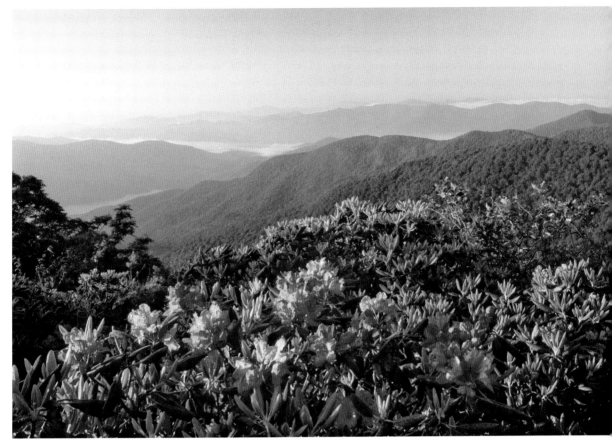

Panorama near Craggy Gardens Visitor Center, MP 365

Summer

Summer starts with the Catawba rhododendron and flame azalea giving a brief explosion of color on the high crests and along the rights of way. A short time later the pinkish rhododendron maximus and the strange little blossoms of the mountain laurel appear, to begin their monthlong run. These fade by late August, leaving the white, splayed heads of Queen Anne's lace as the dominant flower. Wild berries also become plump and colorful in early August, particularly that omnipresent weed, the wild blackberry.

The transition from spring to summer weather can occur anytime between the last week of May and the second week of July. Unlike spring, summer weather is dominated by still, hot air made unstable by uneven heating of the highest crests. The highest temperatures run around 90 degrees at the lowest elevations, and about 85 degrees along the crests. For relief from the heat go higher up, where the 6,000-foot elevations in the Great Balsam and Black mountains seldom get higher than 75 degrees. They get a lot of rain, though. Thunderstorms, fundamentally unpredictable, blow up randomly and can drift in any direction. The air is humid, and hazy enough to obstruct views; there is frequently a gray-colored layer that ends abruptly at around

4,000 feet, spoiling long-range views from the high peaks. Should you be unlucky enough to encounter this, concentrate on forest pictures, where haze gives you the advantages of sunlight without the harsh contrast.

These are the typical conditions, but your experience may vary. The year in which I am writing we had brutal, hazy 90- to 95-degree weather during the first ten days of June—then had more than two weeks of crystalline air, barely reaching 80 degrees, in mid-August. It's largely a matter of luck.

Autumn

Autumn is the most popular season for the parkway—and little wonder. With more than 130 tree species along the Blue Ridge, color is varied, abundant, and long lasting. Altitude change adds to the variety, with color starting above 5,000 feet in early to mid-October, then gradually making its way downhill. Timing and coloration are, however, highly unpredictable. In some years color starts late and slowly creeps downhill, so that the upper elevations go bare weeks before the deepest valleys reach full color. In other years, the whole parkway seems to burst into color within the same week for a short, spectacular display. In a typical year, color peaks around October 15, but when the weather continues warm and dry into September and October, expect a peak in late October and even November.

Leaves are not the only source of color in the fall. Goldenrods and asters erupt in fields and meadows, while dogwoods give photographers a second chance, with their colorful berries. Wildflowers and berries appear well in advance of the leaf change.

Sometime between early August and late September the summer's blue haze will end, giving way to piercingly clear air, intense colors, and unhindered visibility. When you arise in the morning, however, you may find yourself enveloped in a fog that can take until 10 AM to burn off. Do not let this discourage you. This is nearly always "valley fog," a common phenomenon in which cold air slides down off the peaks around dawn to pool in the valleys, causing a dense mist confined to the lowest elevations. This is a marvelous photographic subject, easily captured from the parkway.

Winter

Even in the best years the trees will be bare by mid-November. Significant accumulating snow can fall as early as Thanksgiving and as late as mid-April, but the best chances for good snow pictures are from late December to early March. Ground warmth is the culprit here. Most snows accumulate only a few inches and melt quickly, from the bottom up. In fact, sunlight on natural snow is quite rare, as cold-weather events nearly always have a large trail of overcast behind them that fails to clear until the snow is wet and spotty—or gone completely. A heavy snow event, followed by clear weather, is to be exploited aggressively by the photographer. Many years, no such snow event happens.

As you would expect, the mile-high peaks of the Balsams, the Smokies, and the Blacks can form exceptions to this, being 15 to 30 degrees colder than the lowest valleys and tending to have higher precipitation. The bad news: rangers close the parkway whenever it has a significant snow cover, or whenever its tunnels freeze—and keep it closed until it melts naturally. In practice, this means that the highest sections are closed in November and stay closed well into April.

Taking Better Pictures

Equipment and Technique

I've already mentioned how much a **tripod** can improve nearly every shot, not just by improv-

ing resolution (and honestly, how many of your pictures are too sharp?), but also by improving your artistic control. I carry two tripods in my vehicle at all times: a lightweight Gitzo, and a Manfrotto that weighs 15 pounds and extends to 6 feet. Each cost me about $300, and each is over 10 years old. The Manfrotto is particularly good in the Blue Ridge Mountains, as I can set up sturdy and level on near-cliffs by simply extending one leg downhill. The Gitzo, on the other hand, is superb when I have to walk any distance. Whatever you choose, you'll want to spend a bit extra to make sure it's sturdy, can be adjusted with simple tools, and offers replacement parts.

In order to get top pictures you don't necessarily need a top **camera**—but it helps. I personally cannot imagine using a camera that doesn't allow me to change lenses. Nor do I use zoom lenses; a zoom is always a compromise between flexibility and quality. However, these are only preferences, an approach that has worked well for me for decades. Other excellent photographers use other approaches. If you wish to publish your pictures in top magazines, you'll either need at least 12 megapixels of resolving power, or transparency (slide) film.

Lenses are another area of personal preference. I carry a number of fixed-focal-length lenses and no zooms; this is less bothersome than it sounds, as it's easy to change lenses on a tripod-mounted camera. Here is my typical bag when I go out to photograph the Blue Ridge Parkway from the back of my car, with all lenses given for 35mm full frame: 21mm (which yields an almost 90-degree field of view), 28mm, 50mm, 90mm, and 135mm. For photographing wildlife on the parkway, I recommend a 200mm and a beanbag. Open your car window, rest the beanbag on the sill, and rest your lens on the beanbag. Wildlife is very skittish of people, but it frequently ignores cars.

I used to carry a raft of different filters, but now I am down to one—a **polarizer**. This is

Moving a few yards and changing a lens yields completely different pictures, at MP 317 near the Linville River Picnic Area

the one filter that cannot be replaced in Photoshop. When the sun is over your shoulder, its light will bounce randomly off shiny objects, including the sky (which is full of shiny water vapor). This gives everything an ugly bluish cast. A polarizing filter removes the scattered light, allowing only the directly reflected light (about 25 percent of the total light) to enter your camera. It eliminates the bluish cast and replaces it with vibrant, saturated colors. It is imperative that you use a polarizer under overcast skies; even though you will have a hard time seeing the difference in your viewfinder, the final results will be dramatic. Once you get used to your polarizer you will hunt out pictures where your shoulder points to the sun. I like it so much that I always keep a polarizer on every lens except the 21mm.

Depth of field is crucial to telling a story with your photograph. This is the amount of your image that is in focus from front to back. It increases as your aperture gets smaller and your shutter speed gets slower. (This means that slower shutter speeds yield sharper pictures—but only if you use a tripod.) A professional-quality camera should have a mode that allows you to preview this. However, there's a better way, a technique called barrel focusing. If you look at your lens barrel, you will see that the focus ring has marks that indicate distance, with an infinity symbol at the far right. Opposite this is a fixed ring with marks that indicate f-stops (aperture settings), bracketing the focus marks. To get maximum depth of field, set the aperture to its smallest (slowest shutter speed) setting, then set the infinity mark where it just barely touches the rightmost f-stop mark. You now have the maximum depth of field your lens allows. One of my lenses, a Tamron 28mm that stops down to f32, can focus everything from 18 inches to infinity, perfect for placing a single flower in front of a panoramic view.

Finally, let's talk a little about **exposure**, that is, setting the aperture/f-stop. If your camera is less than 20 years old it has a lot of complex gizmos that do this automatically—and if you don't understand all of them, in detail, it does them wrong. I find it easier to turn all of this nonsense off and set the exposure manually. I do this by setting the exposure mode to "spot meter," which reads the correct exposure off a tiny spot at the center of the rangefinder. The trick is to know where to put the spot. For the parkway, this turns out to be very easy: green grass in full sunshine will always give the correct reading. Under the forest canopy in an overcast, use the leaf litter on the forest floor. You can also use a gray card (a piece of gray cardboard designed to give the perfect spot reading), but I've found metering off the grass to be far more reliable, as grass produces less glare than a piece of cardboard.

Digital Hints

Here's a couple of hints to make your digital (and scanned film) photography better.

First, let's talk about formats and compression. Most digital cameras store their images using a format called JPEG (pronounced JAY-peg). This is favored because (1) it can be easily used by all computers and all Internet browsers, and (2) it takes up the least amount of hard-drive space. The second point is the problem. JPEG compresses the image in a way that only approximates the original; this is called lossy compression, because it loses quality each time it runs. (Think of making a photocopy of a photocopy.) If you are serious about your photography, you will want to save your images using the TIFF format. This will give you much bigger file sizes (some of mine reach a half a gigabyte once adjusted in Photoshop), but will never lose quality by copying—not even a little bit.

The second point has to do with color. Your digital camera (and film scanner) creates color

the same way as your TV and your computer monitor, with three separate components: one red, one green, and one blue (called RGB). This is done with light sensors arranged in a pattern. Each sensor is covered with one of the three colors so that, when exposed to light, it produces a number between 0 and 255 that represents the amount of that color to add to the mix. (A pro-quality camera will subdivide this same "color space" into 65,535 gradations instead of 255 for finer color differences, something called 16-bit color.)

The RGB method leads to a nasty little problem. First, let's pick a color at random, say 80 percent red, 20 percent green, and 40 percent blue. What exactly is this supposed to look like? The screen on your camera's back will show it one way, but your computer will show it another way, and your laptop a third way; that's because their sensors are all different, typically by a lot. Okay, but which, if any, is right? What does "right" even mean in this context? This is called color management; you need a color reference to tell you what 80-20-40 is supposed to look like, so you can correct and synchronize your equipment. If you sell your pictures, your buyers will be using the same color reference (it's an international standard), so they will see them the same way you do. To do this, you need color-correction hardware as well as software—a gizmo that will read the color your computer screen is showing when it is displaying 80-20-40, and correct your screen to the standard. There are several good alternatives; I use Spyder2 from Color-Vision, which gives good results at a reasonable price. (By the way, I actually did pick 80-20-40 at random; it turns out to be a muddy dark-reddish purple.)

Film users have fewer color problems. Transparencies are WYSIWYG (what you see is what you get), their colors fixed and clearly visible. To manage color with transparencies, purchase a color-corrected light table, for as little as $50. The slides' colors will be officially "correct" when you view them on such a table. You still need color-correction hardware/software as soon as you scan your film and view it on a monitor—but you can compare what you see on the screen to the correct version on the light table, something you can't do when you use a digital camera.

Depth of field adds character to this view at Vance Birthplace, near MP 376

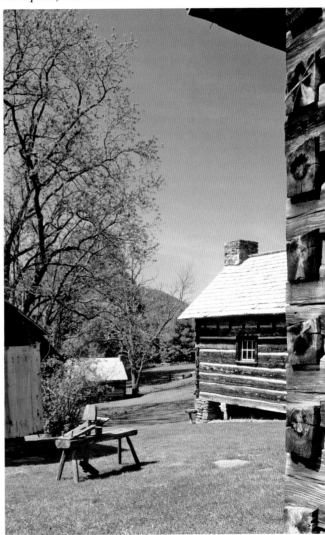

The parkway near Montebello, MP 28

The Parkway in Virginia

I. The Start of the Parkway (Milepost 0 to Milepost 46)

Where: Central Virginia, immediately south of the Shenandoah National Park; the nearest cities are Charlottesville on the east and Lexington on the west.

Noted for: Rough mountain wilderness, ridge-top meadows, wildflowers, wineries, waterfalls, cliffs, and a restored mountain farm.

Watch for: Gasoline is available only at the southern and northern ends of this segment.

Facilities: Humpback Rocks Visitor Center (MP 5.8) has information, restrooms, souvenirs, and picnicking. Whetstone Ridge (MP 29), which once had a restaurant and visitor center, now furnishes only restrooms.

Sleeps and Eats: There are facilities at all three of the major access points, as well as a full-service resort, Wintergreen, adjacent to the parkway off VA 664 at MP 13.7.

General Description: The first 46 miles of the Blue Ridge Parkway explore the widest and wildest section of Virginia's Blue Ridge. These mountains form an oval where rounded peaks group randomly together and the parkway runs through its center. Here you'll find large tracts of the Jefferson National Forest, including four congressionally designated wildernesses (one of them a "scenic area," basically a wilderness that allows bicycles). And wilderness isn't the only attraction here. Mountain farmers once found the high rounded mountaintops to be attractive for pastureland, and this survives in some places. Around Montebello (starting about MP 25) you'll find wide vistas over

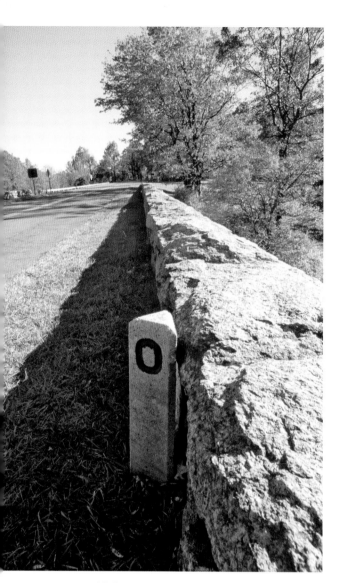

Rockfish Gap

tains. The south end, at MP 45, is reached via US 60 from Buena Vista.

Milepost Zero: Rockfish Gap (1)

Rockfish Gap marks the point where the Shenandoah National Park's Skyline Drive seamlessly merges into the Blue Ridge Parkway. It does this on an arched bridge of dressed stone with a grassy verge, where you'll find the parkway's first milepost: Milepost 0. The marker is in direct sun from early morning to early afternoon, after which the bridge's stone parapet puts it into shadow.

Off the Parkway: Vineyards of Rockfish Valley, Milepost 0, then 4.1 miles (2)

In the last 30 years Virginia's wine industry has grown from just a handful of wineries to over a hundred. At the north end of the parkway, along its eastern slopes, you'll find one of the largest concentrations of wineries in the state. Two, Veritas Winery and Afton Mountain Vineyards, are particularly worth your time, with handsome hilltop centers surrounded by vineyards, and views westward to the Blue Ridge, just 0.5 miles away and 1,000 feet up. To reach Veritas, take US 250 east from Rockfish Gap for 1.3 miles to a very sharp right onto VA 6 (Afton Mountain Road), then go 2.2 miles to the winery. For Afton Mountain, proceed as for Veritas but leave VA 6 after only 1.6 miles by making a right onto Mountain Road (SSR 631), then go 1.2 miles. For more information visit www.veritaswines.com and www.afton mountainvineyards.com.

Views of Rockfish Valley, Milepost 0 to Milepost 2 (3)

The parkway starts off with a set of stunning views to your left over the wine-growing Rockfish Valley. The first view comes up fast, at Afton Overlook (MP 0.2), showing this mountain valley opening up into the Piedmont to the north, with the city of Charlottesville

modern hayfields, the largest concentration of these on the parkway.

Directions: Northern access to MP 0 is via I-64 as it runs between Charlottesville and Staunton; leave at Exit 99, then go right for 0.3 miles on US 250. You can reach the center of this section at MP 27 via VA 56, a steep and curvy highway through the thick of the moun-

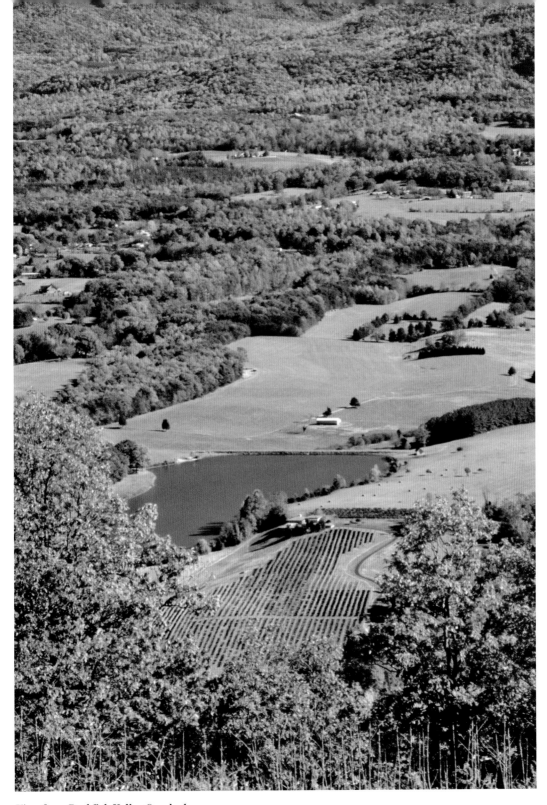

View from Rockfish Valley Overlook

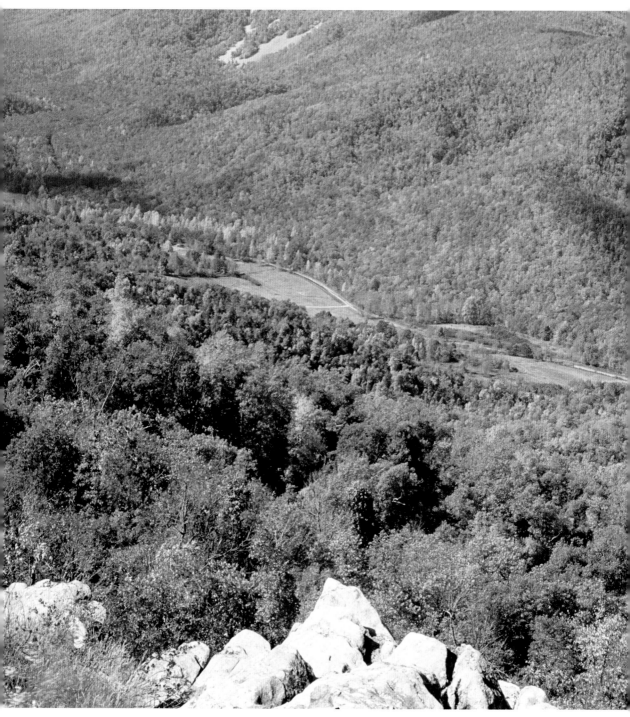

View from Ravens Roost Overlook

visible in the background on a clear day. There's another good view from the roadside on your left at MP 0.7, but the best view comes at Rockfish Valley Overlook, MP 1.5—a full 180-degree pan, with Afton Mountain Vineyards clearly visible directly below you.

String of Pearls: Humpback Rocks, Milepost 5.8 to Milepost 6 (4)

Humpback Rocks, the first of the parkway's "pearls," encompasses two distinct attractions. First, at MP 5.8, is the Humpback Rocks Visitor Center and Mountain Farm Museum, a gathering of a half-dozen 19th-century log buildings from this area, attractively grouped to represent a mountain farm. During the summer season you can tour the furnished buildings, which are staffed by costumed interpreters and crafters. Then, at MP 6, Humpback Gap Overlook provides the closest parking for a walk up to Humpback Rocks, featuring an immense crag that you can safely walk out on, with a breathtaking drop and 270-degree panoramic views. From across a cleft, you can take a picture of someone standing on the outcrop, looking for all the world like a mountain climber. The rocks are 1.1 miles from the parking area, and the journey entails a strenuous 700-foot climb. If you continue south along the trail for another 1.2 miles, an easier 300-foot climb takes you to the summit of Humpback Mountain, which offers additional views.

Shenandoah Valley Views, Milepost 8 to Milepost 11 (5)

Just beyond the Humpback Mountain Picnic Area there are tremendous roadside views over the Shenandoah Valley on your right, starting at Greenstone Overlook (MP 8.8), and again at Rockpoint Overlook (MP 10.4) and Ravens Roost Overlook (MP 10.7). The Greenstone Overlook has a short (0.2 mile) geological interpretive trail that loops through crags, with outcrop views. On the roadside in front of you

is a sweeping vista that includes the parkway itself, bordered by a low rock wall. At Ravens Roost Overlook, a large cliff top offers panoramic views framed by pines twisted into bonsai forms; it's a popular climbing rock as well.

St. Marys Wilderness, Milepost 22 to Milepost 27 (6)

Virginia's largest wilderness borders the parkway for 5 miles, then extends westward over the mountain-ringed watershed of the St. Mary River. This 11,000-acre area has never been logged, making it one of the East's largest virgin forests—although old railroad grades lead to abandoned mines. The lower reaches, accessed from the Shenandoah Valley, are very popular, with a handsome waterfall and deep swimming holes. The upper portions, little visited, feature abandoned mines, virgin forests, quartzite cliffs, and a natural mountaintop pond, very rare in these parts. There's a good overnight loop hike from the Blue Ridge Parkway (MP 23.4), requiring a night's rough camping in the wilderness. Be sure to contact the U.S. Forest Service for a map of this area before exploring it, as trails are unsigned and unmaintained.

The Fields of Montebello, Milepost 24 to Milepost 31 (7)

The St. Marys Wilderness gradually merges with the mountaintop settlement of Montebello over wide meadows. Here the parkway's right-of-way is leased to local farmers and kept in hay, resulting in continuous rural views toward the roadway's adjacent farms. While most of the views are to your left over steeply rolling countryside, at MP 26 you'll get an excellent mountain view on your right, over the wilder-

The parkway near Big Spy Mountain Overlook, St. Marys Wilderness, MP 26.3

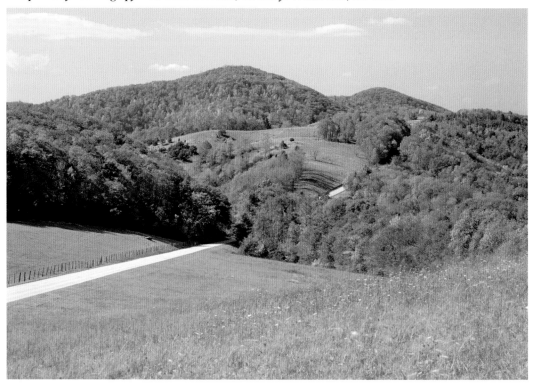

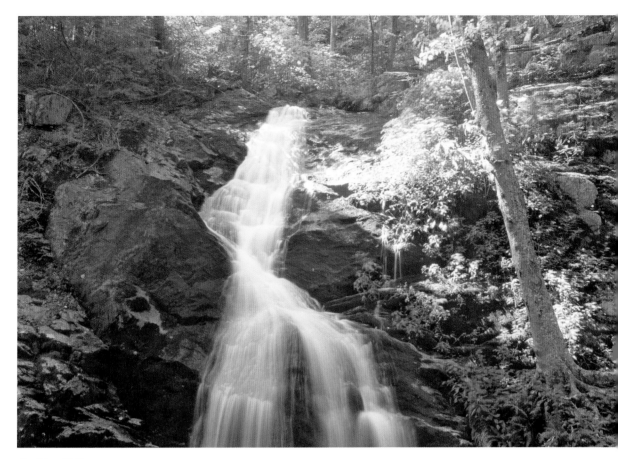

Crabtree Falls

ness, with Big Spy Mountain prominent. At 26.9, wide meadows on your right will tempt you to leave your car and wander on foot, looking for wildflowers; do not resist. The views continue after you cross VA 56, which gives access to the wildernesses as well as to Crabtree Falls. Just slow down and pick your spot.

Off the Parkway: Crabtree Falls, Milepost 27.2, then 6.2 miles (8)

This classic Blue Ridge waterfall rivals any for beauty, adventure, and just plain fun. Its recently rebuilt access trail uses a dozen switchbacks to reach a half-dozen spectacular views without ever becoming steep, rough, or dangerous. It even has disabled access to the lowermost (and perhaps the finest) overlook. Rhododendrons surround the waterfall and trees shade it, yet because the Blue Ridge is so cliff-like, its bedrock so exposed and vertical, views are frequent.

The access trail is one of the best parts of this attraction. The first section is easy and paved, leading to the spectacular view at the base of the falls. From there the path goes up and up, in switchbacks and stairs, on ledges and under cliffs, with stone steps and handsome rustic rails—always something different and interesting that makes you want to stop and take a picture.

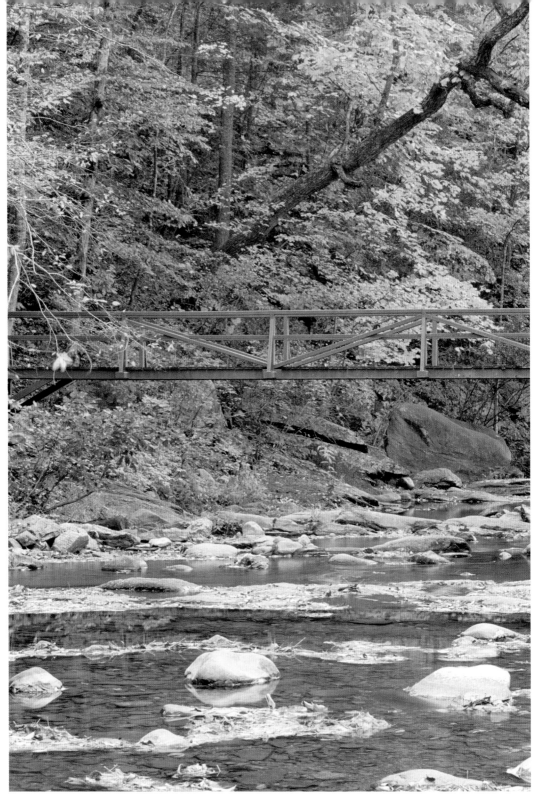

Otter Creek from Lower Otter Creek Overlook, MP 62

II. Peaks of Otter (Milepost 46 to Milepost 105)

General Description: Visually, this segment of the parkway appears to be an extension of the last, with high crest views over rugged and convoluted topography, alternating with forests. There is a subtle difference, however. Starting at the US 60 intersection (MP 45.6), the Blue Ridge itself narrows, becoming a single ridge that rises up to 3,600 feet above the Piedmont, then drops just as much down the other side to the western valleys. Following it, first on one side then another, are a series of low side ridges, and it is these that give a mountainous look to the views. The side ridges have peaks typically 0.5 miles above their valley floors, yet 1,000 feet below you; this yields a sense of drama that will not be matched until the parkway's wild end in the Great Balsam Mountains, almost 400 miles ahead.

Directions: The northern edge is reached from US 60, 4 miles east of Buena Vista. The center is reached via US 501, running between Lynchburg and Glasgow via the James River Water Gap; note that VA 130, which parallels US 501 a few miles to its north, is much the better-quality road. Farther down, VA 43, a scenic but bad-quality mountain road, runs eastward from Bedford, directly through Peaks of Otter, then down to Buchanan. Finally, the southern edge is reached at US 221, 9 miles north of Roanoke.

Buena Vista Overlook, Milepost 45.7 (9)

This overlook gives a 180-degree panorama over the Shenandoah Valley, with the small town of Buena Vista in the distance. The overlook will give you your first chance to explore what those side ridges can do for your landscape shots. This is a good location for a sunset photograph.

Where: Central Virginia, between Lexington and Roanoke.
Noted for: Dramatic mountain scenery, a restored mountain farm, and the James River Water Gap.
Watch for: Gasoline is available only at the northern and southern ends of this segment.
Facilities: Otter Creek has a seasonally open café and gift shop, and a campground open all year. James River Visitor Center has picnicking and a gift shop. Peaks of Otter has camping, picnicking, lodging, a restaurant, and a gift shop.
Sleeps and Eats: Along the parkway, there are cafés at Otter Creek and Peaks of Otter, and a lodge at Peaks of Otter. Off the parkway, Buena Vista at the northern edge of this section has the closest gas, food, and lodging. Farther along, the I-81 corridor is only a dozen miles to the west, with a full range of facilities. Roanoke, at the southern edge, has superb facilities of all types.

String of Pearls: Otter Creek, Milepost 55 to Milepost 63 (10)

The parkway follows Otter Creek, which has carved a fairly wide and gentle valley into the mountainside, down to its James River crossing. The creek joins the parkway as a small stream; unless you are paying attention to the mileposts, you probably won't notice it until, after a mile or two, it dances into view. As you and the creek descend together, four overlooks give you the opportunity to admire the area's beautiful mixed forest, its cascades and rapids, and its developing gorge walls. Starting at the campground (MP 60.8), an easy footpath parallels the creek all the way to its mouth. At

Milepost 63.1, the parkway passes Otter Lake, with its stone dam, built to give a scenic focus to this stretch, and a visual finale.

String of Pearls: James River Visitor Center, Milepost 63.6 (11)

This handsome visitor center explores Virginia's most important river, the James, at the point where it slices through the Blue Ridge. The Trail of Trees forms a short, easy loop along the cliff-like north bank of the water gap. The Canal Trail crosses the James River on the amazing pedestrian walkway of the James River Bridge, then descends to broad, grassy flats on the south bank. Here you can poke around the remnants of the antebellum canal that passed through here, including a reconstructed canal lock. The bridge itself is very impressive, and best photographed from the far bank.

Off the Parkway: James River Water Gap, Milepost 63.9, then 3.8 miles (12)

The Blue Ridge exists in its present form precisely because it's too tough to cut through, a half-billion-year-old stump of an ancient, long-buried Alpine range. Apart from the mighty Potomac, only one river has managed this feat: the James. US 501 follows the James's gorge westward from the parkway, hugging the river and offering many stunning views, before reaching the shrunken town of Glasgow. At 3 miles the highway crosses the river at a small hydro dam, then continues upstream along the lakeshore. At 3.8 miles the Appalachian Trail reaches the highway. Here the trail crosses the James on a spectacular footbridge, 300 yards long, perched high on old piers from a long-abandoned railroad trestle; it's a worthy subject in itself, a good place for views, and a fun walk. On the other side, the trail enters the James River Face Wilderness, where it follows the river's right bank upstream for a mile before turning uphill to explore the wilderness's side valleys and steep, oddly twisting crests.

Climbing Up from the Water Gap, Milepost 63.9 to Milepost 76.6

In this 12.7-mile stretch the parkway climbs from an elevation of 649 feet, its lowest point, to one of 3,950 feet, its highest point in Virginia. At MP 69.1 you will have gained enough altitude to get your first in a series of wide Water Gap views (13), this one over the James River running out of its water gap and into the Piedmont. At MP 71 you pass Petites Gap Road (SSR 781/FR 35); here the Appalachian Trail loops close to the parkway, to follow it on the crest of Thunder Ridge high above you. Thunder Ridge Overlook (MP 74.8) marks the beginning of a series of tremendous views over the Great Valley to the west, and the Devil's Marbleyard within the James River Face Wilderness becomes a clear part of the view from the verge ahead to the right. Along this stretch, Arnold Valley Overlook (MP 75.2) offers outcrops and cliffs for additional interest. The Appalachian Trail crosses the parkway at Thunder Ridge Overlook, then recrosses it at MP 76.3 to skirt just below the meadow-covered summit of Apple Orchard Mountain (14), whose large radar tower is prominently visible from the parkway. The trail circles Apple Orchard Mountain on its west for 0.8 miles with a side trail leading to the top, an elevation gain of 200 feet.

Off the Parkway: James River Face Wilderness (15) and Thunder Ridge Wilderness (16), Milepost 71

These two wilderness areas occupy much of the high Blue Ridge mountains to the right of the parkway, separated from each other by the gravel-surfaced FR 35 (SSR 781, Petites Gap Road), which intersects the parkway at MP 71. With so long a road border, both have excellent trail access, including 14 miles of the Appalachian Trail. Of particular note is the Devil's Marbleyard, a huge field of truck-size boulders

James River Bridge

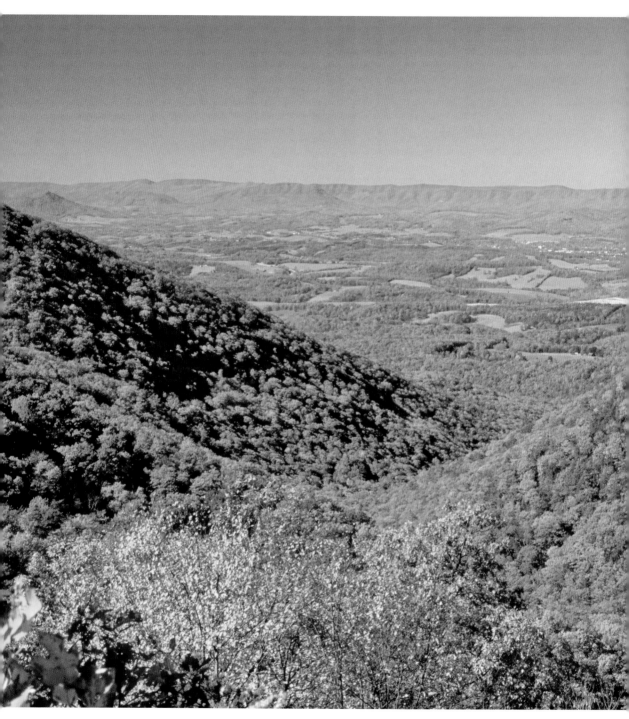

View from Buena Vista Overlook

formed from a collapsed ledge of superhard quartzite, a good subject in itself and one that yields fantastic views. The 2.8-mile round-trip involves 900 feet of climbing; the trailhead is 4.2 miles downhill on FS 35. It's also worthwhile to follow the Appalachian Trail northward from the Thunder Ridge Overlook, as it runs along a high, craggy ridgeline, through a mature hardwood forest with occasional outcrop views.

String of Pearls: Peaks of Otter, Milepost 83 to Milepost 87 (17)

One of the Blue Ridge's most beautiful perched valleys, Peaks of Otter is a triangular bowl 2,500 feet in elevation, surrounded by three high peaks. It's been a tourist destination since at least the 1830s, when Polly Wood set up a small log cabin as an inn, known as Polly Wood's Ordinary, still in existence in its original location and open to visitors. What you will find here, first of all, is a charming park landscape with views over pretty little Abbott Lake toward Peaks of Otter Lodge, a motel-like structure built in the early 1960s. A handsome path leads around the lake, landscaped in dogwoods and rhododendrons; Polly Wood's Ordinary is downhill from the lake on the path to a picnic area. Ahead on the left is Sharp Top Mountain, cone-shaped and with wide views from its crag-bound summit, a 1,300-foot climb that can be avoided by taking a shuttle bus in season (a remnant of a 1920s attraction). The stone-built shelter at the top dates from the early 20th century. The crags themselves are impressive, and should be worked into your views.

Johnson Farm is the only 19th-century farmstead in the Peaks of Otter community not razed by the park service during the parkway's creation. Four of the site's nine original buildings were preserved in a badly altered state thought at the time to represent a "pioneer" farm. Thankfully, the park service has now

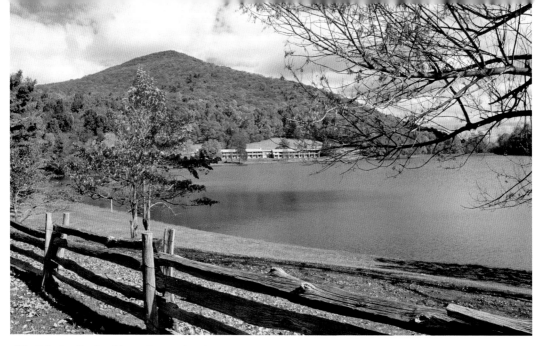

Abbott Lake, Peaks of Otter Recreation Area

restored the farmstead to its 1920s appearance, the log farmhouse made cozy with weatherboarding and friendly with a veranda. Reached by a level path, it's now a fine photo location.

Razor's Edge, Milepost 87 to Milepost 104

The 3-mile stretch of parkway just past Peaks of Otter is an unusually enjoyable forest drive, worthy of multiple stops (particularly in overcast or foggy weather, when the forest photographs at its best). Then the Appalachian Trail rejoins the parkway and crosses it, at MP 90.9. After that you want sunshine, brilliant and bright, for some of the finest mountain panoramas on the parkway.

For it is here that the parkway revels in one of the Blue Ridge's most distinctive features, its razor's-edge ridgeline—elsewhere carefully avoided by the roadway's designer for obvious engineering reasons. At MP 92 the parkway gains a crest so narrow that it is frequently barely wide enough to hold the roadway. The views are panoramic and breathtaking, off both

sides of the road, although 80 years of tree growth now prevent you from getting both at the same time. Be sure to look for pictures that tell the story of the roadway as well as its views. A good place for this is **Pine Tree Overlook (18)** (MP 95.2), with an eastern panorama, then Harvey's Knob Overlook (MP 95.3), with a western panorama. You can park on the verge above the first and below the second, and shoot down at the overlook and roadway, which can result in killer shots, especially if you've got a willing subject posing for you on the overlook below. Pine Tree Overlook is named for its one lone giant pine, long dead and bereft of bark, either adding character or spoiling the view (your choice). At **Taylors Mountain Overlook (19)** (MP 96.9) the Appalachian Trail crosses the roadway on your right, for the last time, for here it swerves west to enjoy wilder lands on the other side of the western valleys. This is a good place to take its portrait, particularly in the late morning (when it gets full sun) or in overcast.

View toward the James River from Mills Gap Overlook, MP 92

Urban intrusion at the Norfolk & Western Overlook

III. Roanoke (Milepost 105 to Milepost 136)

General Description: Roanoke, with a 2008 population of almost 300,000 in the metropolitan area, is the premier mountain city in Virginia and the largest city actually located within (as opposed to near) the southern Appalachian Mountains. It sits astride the only significant gap in the Blue Ridge between Baltimore and Atlanta, and has long been a major transportation hub. By 1881 Roanoke had become the headquarters for the giant Norfolk & Western Railroad; the N&W's Roanoke Shops built some of the most powerful steam locomotives in history (destined for the railroad's steep coal routes in West Virginia). Although the N&W has since become Norfolk Southern, its headquarters moved to the Virginia coast, Roanoke remains a major rail center, and the Roanoke Shops, immediately adjacent to downtown, remains Norfolk Southern's main repair yard.

Why am I telling you all this? Because the Blue Ridge Parkway comes within 2 miles of downtown Roanoke, and the photography there is great. 'Nuff said.

Directions: The northern edge of this section is reached via US 221, 9 miles north of Roanoke. The southern edge is at US 221, 18 miles south of Roanoke. You can reach downtown Roanoke either via VA 24 at MP 112.2, then west 5.4 miles; or via US 220 at MP 121.5, then north 5.6 miles.

Outskirts, Milepost 105 to Milepost 120 (20)

This stretch of the Blue Ridge Parkway marks a fundamental change in scenery, one that will continue for the next 187 miles. From here all the way to Blowing Rock, North Carolina, pri-

> **Where:** In central Virginia, just off I-81's Exit 143.
> **Noted for:** A large, lively mountain city, filled with historic sites and a major railroad hub.
> **Watch for:** There may be significant commuter traffic on this section of the parkway. Virginia's Explore Park, at MP 115.3, may be closed due to funding shortfalls. Gasoline is not available after MP 121.5 (US 220).
> **Facilities:** Camping at Roanoke Mountain; picnicking at adjacent Mill Mountain Park.
> **Sleeps and Eats:** Need you ask? Roanoke has every facility known to mankind.

vate lands push up against the parkway's borders. These borders were purposely set far back from the roadway, typically at 1,000 feet. At the time the parkway was built, during the depths of the Great Depression, this setback was sufficient; it is no longer. Thus the view here is remarkably different from the parkway planners' original intent. Case in point: with vast increases in suburbanization in this area, the National Park Service has allowed tree screens to grow up along the parkway, blocking views which were once rural and are no longer. Nowadays you'll find two overlooks with decent views. The first, Norfolk & Western Overlook (MP 106.9), shows a wide view of a partially suburbanized valley, with some oddly interesting power lines. The second is from the trail at Stewart Knob Overlook (MP 110.6), an easy 0.1-mile walk from a parking lot.

Roanoke River Gorge, Milepost 114.8 (21)

The parkway crosses the narrow Roanoke River Gorge on a bridge that's 1,000 feet long

Virginia's Explore Park spur road, at MP 115

and 200 feet above the river. A sidewalk allows easy picture taking. On the left (downstream) side, the gorge is owned by the parkway until it disappears out of sight around a bend; heavily forested and with a fine set of rapids, it is best shot in midafternoon. The right (upstream) side presents a clear view of a 1906 power station and dam, still in operation and so quaint that backlighting won't spoil it. The Roanoke River Parking Area, on the left at MP 114.9, has a loop trail that descends to an overlook halfway down the gorge wall, then continues on to the riverbank.

Virginia's Explore Park, Milepost 115.3 (22)

For 20 years this 1,100-acre environmental preserve hosted an ambitious living-history museum, until the state abandoned the former state park in 2005. In 2009 the owner of the site, a nonprofit, was pursuing leasing it to a developer as a family tourist attraction with a water park. That's right—a water park on the Blue Ridge Parkway.

So what's left? The parkway has put in a lovely 1.5-mile spur road to the site entrance, and this remains open at press time. It meanders through wide hilltop fields, then dips into

a lovely little gulch that makes for particularly nice fall color photos. It ends at a visitor center that may be closed by the time you read this. The extensive network of bicycle trails, however, remains open for the time being, as negotiations over the site's future continue.

String of Pearls: Mill Mountain, Milepost 120.5 (23)

A 3.3-mile spur road on the right leads past a National Park Service campground to the City of Roanoke's Mill Mountain Park, a peninsula of mountainous wild surrounded by urban civilization. At 1,750 feet, Mill Mountain stands 850 feet above the Roanoke River, only 0.3 miles away. Downtown Roanoke is only 1.4 miles to the north, and the city of Roanoke surrounds the mountain, at night an ocean of light around an island of quiet. At the end of the spur, at the top of Mill Mountain, is Roanoke's most prominent landmark, a giant illuminated star, from which the views are wide and far. Built in 1949, the red, white, and blue neon star stands 88.5 feet tall, and is the world's largest freestanding electrified star. This is a really fun place to take pictures, and not to be missed at deep twilight.

But there's more. Just down from the Mill Mountain Star overlook is the Mill Mountain Zoological Park, run by an independent nonprofit and accredited by the Association of Zoos and Aquariums. Its collection of 85 animals includes the endangered (and eminently photogenic) species of snow leopards, red pandas, and white-naped cranes. For even more photographic opportunities, walk through the 6-acre native wildflower garden on your way to the zoo entrance.

Off the Parkway: Downtown Roanoke, Milepost 121.6, then 6.3 miles (24)

Downtown Roanoke is a photographer's paradise and a railroad fan's Valhalla. To reach it, take US 220 north at MP 121.6 and follow the signs as it becomes I-581. Street parking is plentiful and free, but limited to two hours at any one spot and aggressively enforced.

The huge Norfolk Southern rail yards form the northern border of downtown, a barrier to development. I recommend driving to the far (northern) side of the rail yard, and parking on Shenandoah Street by the handsome pedestrian overpass. On the north is the

Downtown Roanoke, from the Mill Mountain Star

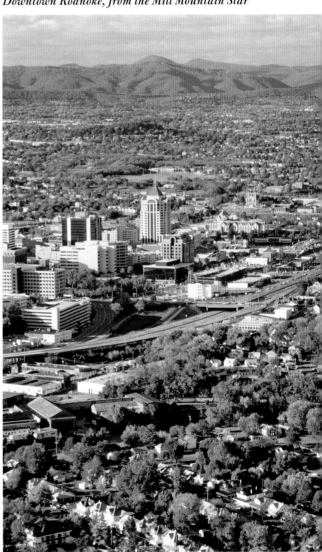

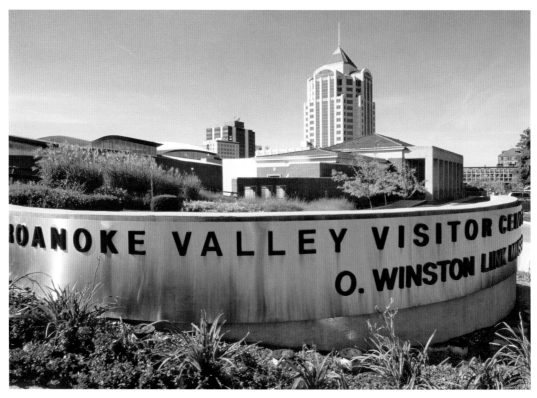

O. Winston Link Museum

Hotel Roanoke, a massive 1882 Tudor structure constructed by the then-new N&W Railroad. It's still a luxury hotel, set in beautiful gardens and fun to photograph. Across the street is the old passenger depot, now a museum dedicated to the great railroad photographer O. Winston Link, noted for his massive photographs of steam locomotives in motion, taken at night with vast banks of flashbulbs. Any photographer worth his or her salt will come away from this amazing display with renewed vision (and, maybe, an N&W cap). The graceful, modernist Market Street Walkway, a pedestrian overpass, gives good views of the yards below, and is a worthy subject in itself. Now you are actually in downtown, and in front of you, along Market Street between Salem Avenue and Kirk Avenue, is the City Market, a farmers' market operating daily in season with booths lining the sidewalks. (Hint: try to hit this with morning sun.) To your left one block (on Salem Avenue) is the Taubman Museum of Art, housed in a strangely angled glass and polished-aluminum structure. To your right four blocks is the Virginia Museum of Transportation, the South's largest collection of locomotives, in the old N&W freight depot. Just beyond the City Market (don't forget to move your car, because by now your time is up) is the Center in the Square, a collection of science, art, and cultural museums in a set of restored buildings around a delightfully urban square. Keep going, and you enter Elmwood Park, several blocks of landscaped parklands giving entry to a series of mostly modern buildings.

View of Roanoke from Mason Knob Overlook, MP 126

A country lane intersects the parkway near the Blue Ridge Music Center, MP 209

IV. The Hills (Milepost 136 to Milepost 217)

General Description: This 81-mile segment of the parkway loses its mountainous character pretty much instantly, as soon as you cross Abney Gap at MP 136. From there on you follow the Eastern Continental Divide, traversing the top of an escarpment, with a thousand-foot drop on your left. Your right side, however, consists of small rolling hills, typically only a hundred feet high and nary a mountain in sight. This right-side scenery is intimate rather than expansive, and will give you your best shots. This pattern continues, with some variation, all the way to the North Carolina line.

Directions: Northern access is via US 221, 18 miles south of Roanoke. Southern access is via VA 89, 7 miles south of Galax, VA, or via NC 89 (same highway, different state) 22 miles west of Mount Airy, NC, and 13 miles west of I-77's Exit 100. Two US highways reach the center of this segment. First, US 58 (running between Hillsville and Stuart) intersects at MP 177.7, just south of Mabry Mill. Then US 53 (running between Hillsville and Mount Airy) intersects at MP 199.4. The parkway does not intersect I-77; to reach it from the interstate, leave I-77 at Exit 8, take VA 148 east 0.7 miles to US 58, and take US 58 south 1 mile to the parkway.

A Long Countryside Drive, Milepost 136 to Milepost 165

This stretch of the parkway was the first one to be designed, and the earliest one open to the public (in 1939). The scenery would have been very different back then. This region, known to geologists as the Blue Ridge Plateau, was more heavily farmed, and the farms were old-fashioned in their methods, even for the day. Since then, arable lands have been given over

Where: South-central Virginia, from Roanoke to the North Carolina state line.

Noted for: Beautiful rural scenery, escarpment views over the Piedmont, wineries, and the much-photographed Mabry Mill.

Watch for: Gasoline is not available for the first 40 miles of this segment; look for gasoline at US 220 (MP 121.5), US 58 (MP 177.7), and US 52 (MP 199.4).

Facilities: Smart View Recreation Area (MP 154.5) has picnicking. Rocky Knob (MP 165.3) offers camping, picnicking, cabins, and a visitor center. Mabry Mill (MP 176.2) has a café and open-air museum. Finally, the Blue Ridge Music Center (MP 213.3) has live music and a visitor center.

Sleeps and Eats: Roanoke, one of the South's great cities, is the obvious choice, only 18 miles from this segment's northern end. The small county seat of Floyd sits at the center of this segment and has remarkably good choices for food, lodging, and entertainment; you'll find it 6.1 miles north of MP 165.6 via VA 8. The two wineries along the parkway offer lunch.

to meadow and forest, drafty, cramped cabins traded in for ranch homes and trailers, and animal power replaced by internal combustion engines. On the plus side, today's inhabitants enjoy a standard of living comparable with the rest of the nation; this area is no longer the poverty pocket it was in the 1930s and '40s.

For these reasons expect your scenery to be pleasant but not (for the most part) remarkable. The parkway has the advantage of giving you much better views of the region's modern farmland than a normal rural road would, allowing

Farm along the parkway, MP 152

you to see the local farmland as the farmers do. The National Park Service intentionally manipulates the parkway's wide right-of-way to coexist with the fields, in many places leasing it to adjacent farmers so that their crops and meadows blend seamlessly with the area bordering the tarmac.

Although the parkway follows the edge of a 1,000-foot escarpment along this entire segment, only three overlooks give a really good roadside view: **Cahas Knob (25)** at MP 139, then Devil's Backbone at MP 143.9, followed by **Pine Spur (26)** a mile later at MP 144.8. Looking straight down at flatlands can be surprisingly dull, however, so Cahas Knob, at the mountainous start of the plateau, will likely yield you the most interesting photos.

String of Pearls: Smart View Recreation Area, Milepost 154.5 (27)

This 500-acre area sits atop the Blue Ridge's escarpment at a particularly steep place; its entrance is 0.4 miles beyond the unremarkable Smart View Overlook, down a short spur road on your left. It was here that the Trail family built a simple log cabin in the 1890s right on the edge, with a stunning 180-degree view from their meadows—"a right smart view." Both the cabin and the view survive, down a short walk from the picnic area parking lot. There's also a 3-mile loop trail that follows the top of the escarpment with less than 200 feet of climb, passing through meadows and forests, crags and streams, and offering many good views; you can pick it up at the Trail Cabin.

String of Pearls: Rocky Knob Recreation Area, Milepost 165.3 to Milepost 169 (28)

This 4,000-acre park is an island of mountain wilderness, noted for its large ridge-top meadows, copious wildflowers, streamside gorge walking, and rocky crags. For the automobile-bound there are three overlooks, all very nice, but for the best views, and photos, you really need to get out and walk. The easiest place to do this is at the entrance to the campground, MP 167.1, where a trail heads forward to your left into meadows, and immediately climbs to vistas not available from the roadway. Very quickly the parkway becomes visible well downhill on your right; you, not the drivers down below, are getting the panoramic views.

The canyon to the east is also part of the park, and furnishes its own set of photo opportunities. It is traversed by a former public road, now closed to vehicles, that links the downhill end at VA 8 with a set of rental cabins, built by the Civilian Conservation Corp in 1935, at the uphill end in 4.2 miles and 1,400 feet of elevation gain. This pleasant walk offers a number of good photographic opportunities, climaxing at the 1916 Austin House at 1.6 miles from the downhill trailhead, privately owned and nicely restored.

Off the Parkway: The Wineries of Rocky Knob, Milepost 170 to Milepost 172

Two handsome wineries sit nearly adjacent to the parkway along the 2-mile stretch immediately south of Rocky Knob. Both offer good photographic opportunities, as well as good wine and food. **Villa Appalachia Winery (29)** produces wines in the Italian style from a large, modern facility modeled after a Tuscan estate—

Rocky Knob Recreation Area, Saddle Overlook, MP 168

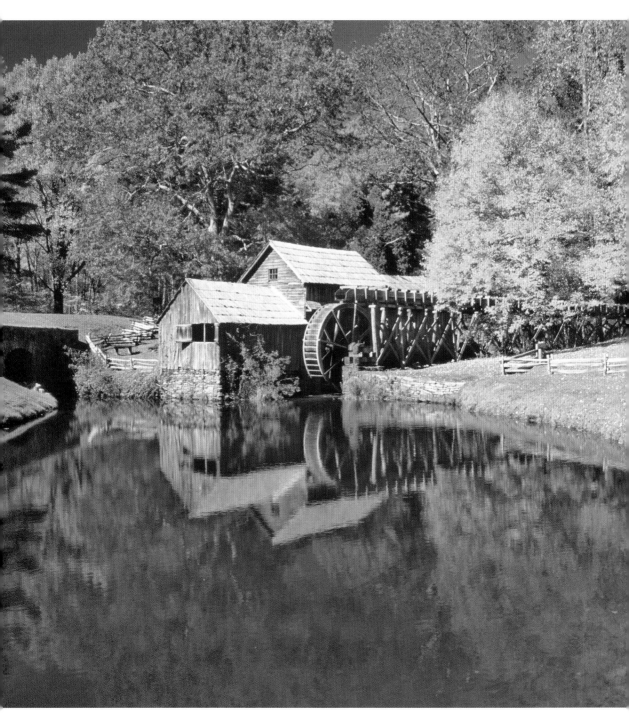

Mabry Mill

up to 3,000 cases a year, all from the winery's own grapes. Tastings are accompanied by Italian bread, pesto, and local cheeses. **Château Morrisette (30)**, open since 1978, is noted for its grand French chateau–style building on a ridge above the Blue Ridge Parkway; inside, it has a castle feel with its wide spaces, high beamed ceiling, and lots of wood and stone, and offers a restaurant serving lunch and dinner as well as tastings. Neither of the wineries are marked from the parkway. For directions and additional information visit www.villa appalaccia.com and www.thedogs.com.

String of Pearls: Mabry Mill, Milepost 176.2 (31)

This is very likely the most beautiful spot on the entire parkway—and without a doubt the most photographed. Ed Mabry built the picturesque overshot mill in 1910, and for a while made a good living from it, using it to grind flour and saw wood. However, after 1930, hard times and disease took its toll, and by the time Mabry died in 1936 the mill was in bad shape. That year the Blue Ridge Parkway acquired its right-of-way here, and the parkway's designer, landscape architect Stanley Abbott, immediately fell in love with this spot. What you see today is as much due to Abbott as to Mabry.

The view over the millpond toward the mill is simply spectacular, and so heavily photographed that it has become an icon of the parkway. Do not let this discourage you; Abbott's design is so good as to present plenty of opportunities to find a new shot of the mill reflected in the still waters. Try to include foreground for context, rhododendrons and wildflowers in the spring, fall colors in the autumn.

Beyond the millpond scene, there are many more things to explore. The 0.5-mile Mountain Industry Trail takes you around the best views, then over to the sophisticated flume, the still-operating mill, a blacksmith shop, a

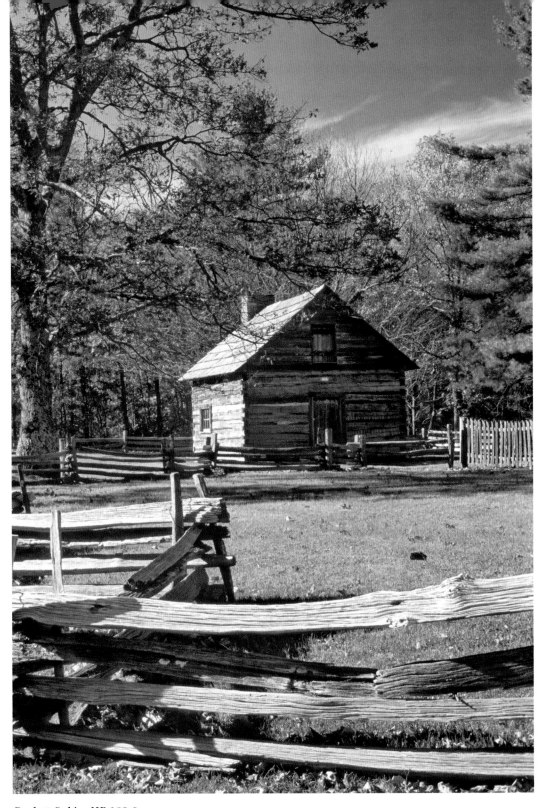

Puckett Cabin, MP 189.9

View from Piedmont Overlook, MP 205

sorghum mill, a farm-implements display, and a moonshine still, with demonstrations held throughout the summer season. There's also a restaurant and gift shop on site.

Along the South-facing Blue Ridge, Milepost 189 to Milepost 209

For 20 miles the parkway closely follows the Blue Ridge as it runs westward. This is a visually disappointing section, far removed from the designer's original intent and frequently degraded by modern development and signage. Nevertheless, there are spots worthy of attention. At the start of the stretch is **Groundhog Mountain (32)** at Milepost 188.9, where a picturesque log fire-tower from 1941 gives good views, once panoramic but now partially blocked by vacation homes. A short distance ahead are the Aunt Orelena Hawks **Puckett Cabin and Bluemont Presbyterian Church (33)** (at Mileposts 189.9 and 191.9), the former being particularly photogenic. Finally, as you reach the far end of this stretch, look for **farm crops along the Parkway (34)** (particularly hay) after Milepost 200. While the formal overlooks in this final section have had their views blocked by post-1933 tree growth, you can walk up the hayfields behind Piedmont Overlook for some decent shots.

String of Pearls: Blue Ridge Music Center, Milepost 213.3 (35)

The parkway's newest "pearl," completed in 2007, sits on a large tract of mountainside donated by the nearby town of Galax. The modern visitor center is more attractive than most postwar parkway buildings, and contains a museum that concentrates almost entirely on Virginia musicians. During the season you'll find local musicians performing live nearly every day, 10 AM to 4 PM. In pleasant weather they'll be on a balcony with rocking chairs, a fine place to take a picture.

Open daily 9 AM to 5 PM May to Oct. Free admission. Call 276-236-5309, or visit www.blueridgemusiccenter.org.

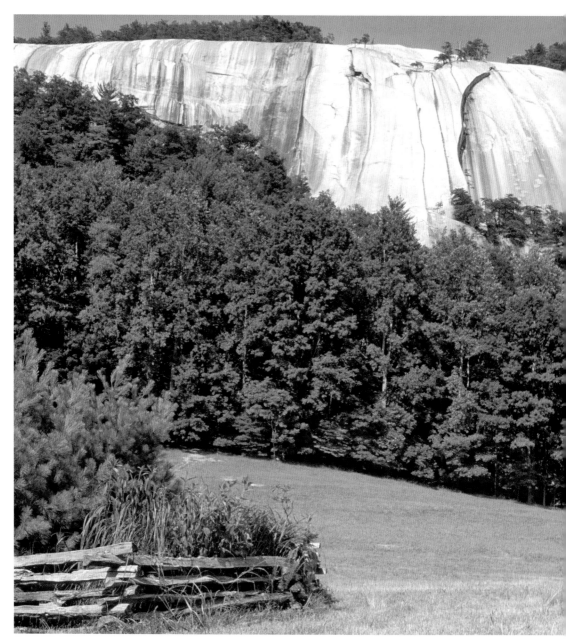

Stone Mountain

V. The Parkway Enters North Carolina (Milepost 217 to Milepost 291)

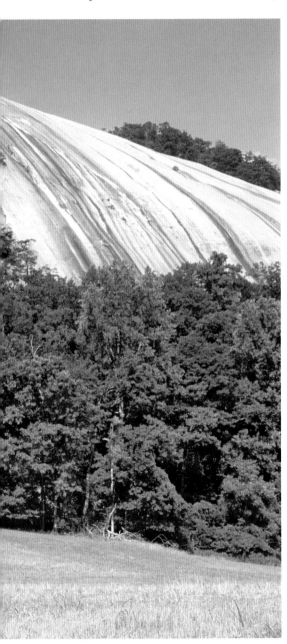

Where: The northwestern corner of North Carolina.

Noted for: Dramatic contrasts between rural beauty and rugged wilderness views, mountain-sized granite domes, waterfalls, wildflower meadows, log cabins.

Facilities: Cumberland Knob (MP 217.9) has picnicking and a visitor center. Doughton Park (MP 241.1) has a visitor center, a café, a lodge, a campground, and a picnic area. E. B. Jeffress Park (MP 271) has picnicking.

Sleeps and Eats: There are fine facilities just north of the parkway at NC 18 (Laurel Springs) and NC 16 (Glendale Springs). For a wide choice of facilities, look into the Boone/Blowing Rock area at the southern end of this segment.

General Description: This section of the parkway gains much of its visual interest from its rapid contrasts between rough wilderness and gentle farmlands. Here the parkway closely follows the crest of the Blue Ridge, the view frequently alternating between the wild, rugged scenery on the east side of the crest and the bowl of prosperous farmland on the west. The eastern edge of the Blue Ridge is eroded into steep, jagged mountains, covered in forests, with thin soil over granite making the land unsuitable for farming, even in the narrow valleys. In places the granite breaks through to form bare open balds—and in one place, Stone Mountain State Park, adjacent to the parkway, you can find mountain-sized outcrops of solid granite, a remarkable sight. The western edge

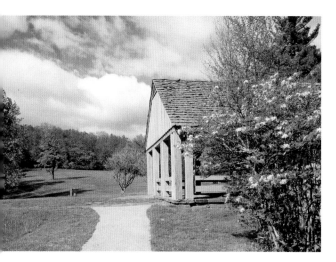

Cumberland Knob Recreation Area

dips gently to the New River Valley, with the view opening suddenly on pastoral prosperity.

Directions: Northern access is via VA 89, 7 miles south of Galax, VA, or via NC 89 (same highway, different state), 22 miles west of Mount Airy, NC, and 13 miles west of I-77's Exit 100. Southern access is via US 321 as it runs between Boone and Hickory. There are several highways that intersect the parkway in between: US 21 goes westward to Sparta at MP 229.6; NC 18, running north-south, at MP 248.1; NC 16, going north to Jefferson at MP 261.2; and US 421, running between Boone and Wilkesboro at MP 276.4. Apart from US 421, expect all highways in this area to be far more steep, narrow, and tightly curved than the parkway.

String of Pearls: Cumberland Knob, Milepost 217.9 (36)

The 1,000-acre Cumberland Knob Recreation Area was the first segment of the Blue Ridge Parkway opened to the public, being the site of the dedication ceremony in 1935. It's a forested knob located a mile south of the Virginia border, adjacent to the parkway's NC

18 exit. It has two pleasant trails, a 1-mile stroll to the top of Cumberland Knob (only 2,840 feet, but the highest point in the area), and a more strenuous 2-mile loop down to Gully Creek—the latter an 800-foot return climb, offering mountain views, deep forests, attractive small waterfalls, and a log barn.

Along the Blue Ridge Crest, Milepost 217 to Milepost 237

This stretch has some nice east-facing views along its first 2 miles, but after that becomes a pleasant rural jaunt. The photo opportunities here are mainly from the roadside—of barns, and back roads, and wildflowers. There are two millponds on the parkway along this stretch, both offering wildlife and attractive scenery, **Hare Mill Pond (37)** at MP 225.2 and **Little Glade Mill Pond (38)** at MP 230.1. The final 7 miles of this segment give a series of dramatic views, westward as well as east. Mahogany Rock Overlook, MP 235, is a fine sunset location.

Off the Parkway: Stone Mountain State Park, Milepost 229.6, then 10.3 miles (39)

Although this 14,000-acre park shares a common boundary with the parkway, you have to drive some 10 miles to reach it; take US 21 south for 4.4 miles to a right onto Stone Mountain Road (SSR 1100), then 3 miles to a right onto Frank Parkway (still SSR 1100), which spends the next 7 miles within the state park.

Created in 1969 when underwear king R. Philip Hanes donated the core holdings, this park centers on Stone Mountain, a 600-foot-tall granite dome immediately under the 1,500-foot Blue Ridge escarpment. It, with two smaller adjacent domes, formed as one underground magma intrusion, now revealed by millions of years of erosion. The best photography is found from the 4.5-mile loop that climbs Stone Mountain itself. Starting at the Hutchin-

son Homestead, the path strolls easily up the grassy valley with great views toward the cliff face of Stone Mountain, then follows a forested stream uphill for a mile or so to the park's most impressive waterfall, Stone Mountain Falls. From here the path becomes quite difficult, although it climbs the mountain's easiest side. Surprisingly, the top is forested, but with wide and changing views from the cliff edges that surround the mile-long summit. Another, much easier loop visits the other two outcrops, Cedar Rock and Wolf Rock.

This by no means exhausts the park's photographic sites. Hutchinson Homestead, the main trailhead, is a post-pioneer farm restored to its 19th-century appearance. Farther down the road, Garden Creek Baptist Church is a 19th-century rural church still in use. Finally, several other waterfalls are scattered about the extensive system of forest trails; these can be found with the help of the park map. For more information call 336-957-8185, or visit www .ncparks.gov/Visit/parks/stmo/main.php.

String of Pearls: Doughton Park, Milepost 241.1 (40)

Originally named Bluff Mountain, this 6,000-acre Blue Ridge Parkway tract includes 6 miles of the Blue Ridge crest and the watershed beneath it. Typical of the Blue Ridge, the Atlantic side is a rugged, broken drop of 2,000 feet, while the western side is little more than rolling

Doughton Park

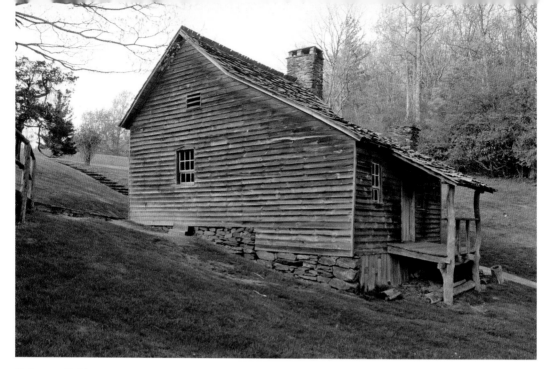
Brinegar Cabin

hills. The crest is especially notable for its large wildflower meadows, and its rocky outcrops with wide views. Paths link the meadows and the outcrops, forming multiple loops that plummet into the stream basin beneath and climb back out again. At the center is a classic parkway recreation area—picnic area, camping area, store, coffee shop, and a motel-style lodge. At the near end is the **Brinegar Cabin (41)** (MP 238.5), built in 1885 and one of the loveliest log cabins in the region; it's the site of weaving demonstrations during the summer.

Off the Parkway: Holy Trinity Church, Milepost 258.6, then 0.5 miles (42)

This rural parish church close to the parkway's NC 16 exit at Glendale Springs is noted for its exquisite fresco in the classic Italian Renaissance manner. It's a simple Carpenter Gothic building from 1901, still serving its Episcopalian congregation. Artist Ben Long, then little known, created the fresco in the 1970s, a moving and original interpretation of the Last Supper. For more information call 336-982-3076.

E. B. Jeffress Park, Milepost 271 to Milepost 275 (43)

The 500-acre recreation area is named after the 1935 North Carolina Department of Roads chief who championed the parkway. Located along the parkway just north of its intersection with US 421, it preserves a 2.9-mile stretch of the Blue Ridge crest, with a typically steep plummet on its Atlantic side and gentle swale toward the back. The park's most popular site is Cascade Falls, a lacy waterfall over a 50-foot granite outcrop that is reached from the picnic area (MP 271.9) via a mile-long footpath. Then, at Thomkins Knob Overlook (MP 272.5), a short footpath leads to a late-19th-century log cabin and a rough log church, in a meadow that's studded with flowers in spring and summer.

Fresco, Holy Trinity Church

Elegant sitting room, Blowing Rock bed & breakfast

VI. Grandfather Mountain (Milepost 291 to Milepost 318)

General Description: This 27-mile section contains more scenic variety than any other on the parkway—a quaintly historic resort village, a grand country home with vast gardens, a treeless and cliff-bound 5,900-foot ridge, a habitat zoo of native mammals, a long curving viaduct renowned as an engineering wonder, and (as a finale) a spectacular waterfall into a wilderness gorge. Well into the 1840s, when the first scientific surveys of the Blue Ridge were made, people believed these peaks to be the highest in the South; you'll see why when you take in the impressive views.

Directions: Northern access is via US 321 as it runs between Boone and Hickory. Southern access is via US 221, which heads south to Marion and I-40. US 221 parallels the parkway along this entire segment. All highways in this section are worse in quality than the parkway—often, much worse.

Off the Parkway: Village of Blowing Rock, Milepost 291.9, then 1.5 miles (44)

This village sits in a shallow bowl just behind the crest of the Blue Ridge, a short distance off the parkway. It's been around since the 1890s, a resort town from the first, and many of the buildings are historic. The model for Mitford, a fictional town the writer Jan Karon featured in a series of best-selling books, Blowing Rock's old village center remains attractive and busy, with a four-block downtown and city park that allows wide views of the afternoon sun striking the storefronts. It's a great place for an overnight stay, with some of the best inns and restaurants in the state (which, in turn, can be good photo subjects).

Where: The central part of the North Carolina mountains, near the small city of Boone, north and uphill from the I-40 corridor towns of Morganton and Marion.

Noted for: Wild mountain views, rocky crags, rare and endangered plants, waterfalls, and an elegant, emparked mansion.

Watch for: Mileposts between 298 and 305 are less than a mile apart, to compensate for this late-completed segment being shorter than anticipated.

Facilities: Moses H. Cone Memorial Park (MP 294) has a craft center. Julian Price Memorial Park (MP 296.7) has camping and picnicking. Linn Cove Viaduct (MP 304.4) has a visitor center. Linville Falls (MP 316.5) has picnicking, camping, and a visitor center.

Sleeps and Eats: The resort town of Blowing Rock is adjacent to the parkway at this segment's northern end, and has some of the best restaurants and lodges in the state. Boone, 6 miles north on US 321, has full urban services and facilities. Starting at MP 305, US 221 parallels the parkway a mile or two to its north with a variety of services.

Broyhill Park, a block west of downtown, also offers some good photo opportunities, with informal gardens and a gazebo around a lovely lake. Below the dam lies Annie Cannon Gardens, a native flower garden. Downstream from Cannon Gardens, a hiking path leads steeply downhill to two large and beautiful waterfalls, a worthwhile if strenuous hike (3 miles round-trip, an 800-foot climb).

Finally, Blowing Rock possesses the only Blue Ridge Parkway overlook that's not actually

on the parkway. The Bass Lake parking area, on US 221, 0.5 miles west of its intersection with Bus US 321 at town center, gives easy access to this beautiful little lake, ringed by carriage paths, in Moses Cone Park.

String of Pearls: Moses H. Cone Memorial Park, Milepost 294 (45)

In the 1890s Greensboro, North Carolina, denim manufacturer Moses Cone and his wife, Bertha, built a summer home for themselves second only to George W. Vanderbilt's Biltmore in resplendence, surrounded by wildflower meadows laced with miles of carriage paths. Today, this estate is Cone Park—a culti-vated landscape of great beauty and richness spread over thousands of acres. Meadowlands stretch uphill from a lake, framed by forests and rhododendrons, to reach the beautiful mansion, now a crafts center run by the Southern Highland Craft Guild. Crossing the parkway behind the manor, the meadows continue uphill, as the carriage path forks to two high-peak views—a 3-mile switchback to Flat Top and a 5-mile spiral to Rich Mountain.

The manor and its craft center will get much of your attention—deservedly so, with its summer craft demonstrations and wide views from a porch well outfitted with rockers. However, the carriage paths are the real marvel of the

Moses Cone House

park. Evenly and gently sloped, they wander through the carefully planned landscape in a series of amazing turns and twists, switchbacks, loops, and spirals, each with its own perspective. The paths are also open to horses (which can be hired in Blowing Rock), for additional photographic interest.

String of Pearls: Julian Price Memorial Park, Milepost 296.7 (46)

This 6.5-square-mile park fills the gap between Moses Cone Park and the privately owned Grandfather Mountain Park. Less wild than Grandfather Mountain, it is more of a typical Blue Ridge landscape, with fields left from grazing and woods left from logging, crossed by trails that are rough and rolling. Its visual centerpiece is the 38-acre Price Lake. The parkway crosses the lake's handsome stone dam at MP 296.7, then circles it on its north shore, with some good views from the parking area (left) at MP 297.3; a path circles the entire lakeshore, for additional views. To explore the grassy meadows left by old farms, take the Tawanha Trail westward from the campground, with the meadows starting at 0.3 miles, then again at 1 mile.

String of Pearls: Slopes of Grandfather Mountain, Milepost 300 to Milepost 305 (47)

As the parkway leaves Price Park, it slabs along the southeastern slope of Grandfather Mountain, at 5,964 feet the highest point on the Blue Ridge—although, as we shall see, the parkway will find taller peaks after it leaves the crest of the Blue Ridge behind. This is a very odd environment indeed, noted for its wide, windblasted heaths and expanses of exposed rock. The downhill side of the parkway gives wide views over the Piedmont, with some of the best coming from the roadside rather than the overlooks. Uphill is a mix of quiet forest, noisy little streams, and exposed rocks, moss, and rhodo-

Price Lake

dendrons—all easily explored via the trails of the Grandfather Mountain backcountry.

For the photographer, **Linn Cove Viaduct (48)** is the main attraction. This 0.25-mile S-shaped viaduct is the longest of several such used to prevent damage to the delicate ecosystem below, and its construction in 1983 pioneered engineering techniques now in common use. It has a visitor center at its western end (MP 304.4), with a viewpoint from below; from it, the Tawanha Trail wanders along its base. Three other locations, however, will give you better views, and better photographs. The first is at Rough Ridge on the Tawanha Trail, whose crest yields panoramic views that include the viaduct; park at Rough Ridge Overlook (MP 302.8) and take the trail south for 300 yards. The second is at the viaduct's eastern end, for a sweeping view along its length; park at Yonahlossee Overlook (MP 303.9) and walk west along the roadside for 0.2 miles (as

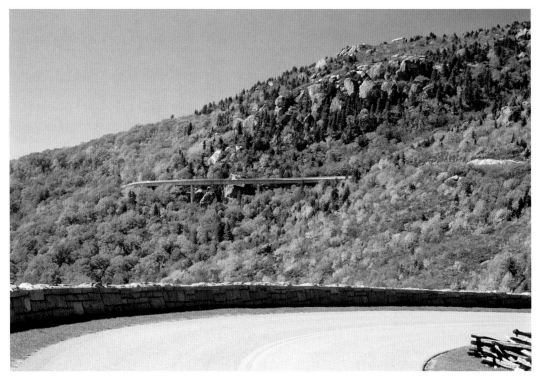

Linn Cove Viaduct, from the Yonahlossee Overlook

verge parking is blocked). Finally, to get a view from below, leave the parkway at US 221 (MP 305) and go south for 0.4 miles to a right onto gravel Edgemont Road (SSR 1514), then go 0.5 miles to an abandoned quarry on your left.

Off the Parkway: Grandfather Mountain Park, MP 305, then 1.1 miles (49)

Privately owned Grandfather Mountain Park describes itself as "a scenic travel attraction"—a theme park where the theme is nature, the environment, and incredible natural beauty. There's a spectacular drive up, a nature center, a first-rate habitat zoo, and a mile-high suspension bridge. The attraction area starts at the park entrance on US 221 1 mile west of the Blue Ridge Parkway, and centers on a 2.2-mile road that climbs a thousand feet up the mountain in eight tight switchbacks. Halfway up is the outstanding habitat zoo, featuring native mountain animals in their actual habitats, with the human visitors separated by moats or elevated walks. The road's last half mile swags steeply up the mountain with wide views over high meadows, then ends at almost exactly 1 mile in elevation, in an area of great open views, meadows, spruce-fir forests, cliffs, and strange rock formations. In the middle of it all is the **Mile-High Swinging Bridge (50)**, almost 100 yards long, crossing a rocky chasm 80 feet deep. An easy 2.5-mile walk goes through the chasm under the bridge, then through boreal forests and across rocky outcrops to a viewpoint overlooking the Blue Ridge Parkway. A second, more challenging walk leads uphill, utilizing cables and ladders to navigate exposed rocks and skirt hoodoos, to a high point of 5,900 feet.

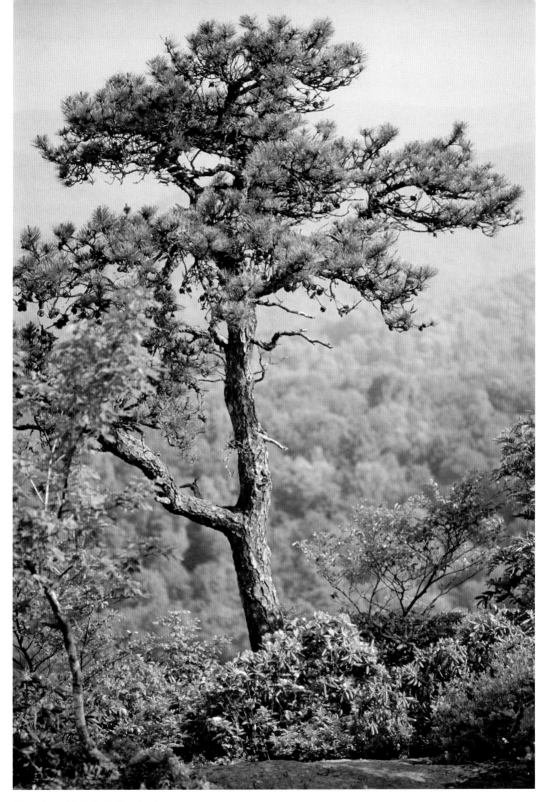

View from Flat Rock Overlook

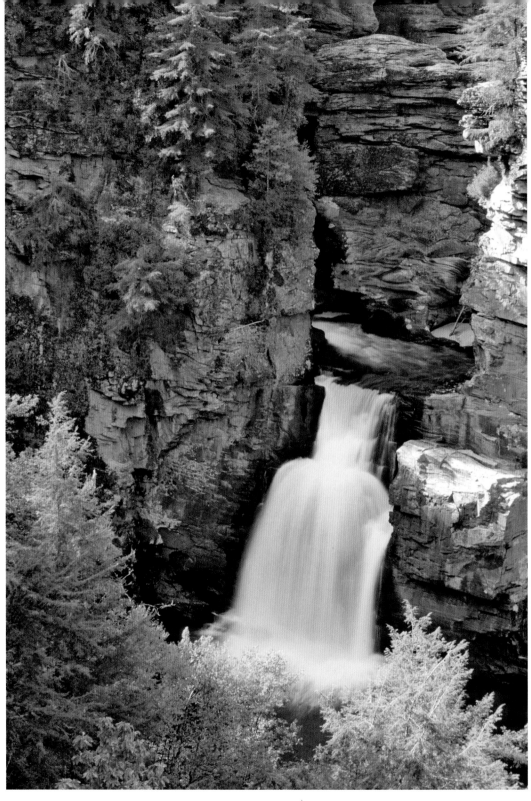

Linville Falls, off Linville spur road, from the right-bank trail

Open 8 AM to 6 PM (9 AM to 5 PM in winter). Adults: $14; seniors: $12; children: $6. Call 800-468-7325, or visit www.grandfather.com.

Two Rocky Balds, Milepost 305 to Milepost 310

This 5-mile stretch presents a number of good views, particularly over the large expanse of mountainous national forest land to the east. Two overlooks, however, stand out for offering their views from extensive rocky balds—cliff-top areas of exposed granitic rock, covered with moss, twisted small trees, and plentiful wildflowers. **Beacon Heights Overlook (51)** (MP 305.1) offers the best view of Grandfather Mountain from the parkway, looking back from its parking area. From there, a 0.25-mile loop trail climbs 150 feet to the top of Beacon Heights, where you will find two rocky balds rimmed by cliffs. An afternoon climb will put good light on this stunning view of Grandfather Mountain. **Flat Rock Overlook (52)** (MP 308.3), a mainly level 0.5-mile loop from the parking lot, is flatter and broader than Beacon Heights, and invading mosses, rhododendrons, and bonsai-like trees are at least as good a subject as the 180-degree west-facing panorama they frame.

String of Pearls: Linville Falls Recreation Area, Milepost 316.5 (53)

This large recreation area stretches along a 3-mile length of the Linville River, climaxing with the tall plunge of Linville Falls. As the parkway approaches the river it enters lovely meadows with split-rail fences. A spur road to the left leads 1.5 miles to the waterfall. The falls occur as the Linville River reaches the upper edge of Linville Gorge (a congressionally designated wilderness) and plunges straight down into it. Trails to the waterfall spread out in fingers from a visitor center at the end of the spur road to various viewpoints. The right bank leads first to a ledge and pool at the top of the waterfall, then to a series of overlooks. The left-bank path leads to a rim-top view toward the waterfall, then a drop to the bottom of the gorge for a view from beneath. The shortest walk is a level 1-mile round trip, while visiting all six overlooks will require about 5 miles of strenuous climbing.

Grandfather Mountain, viewed from Beacon Heights Overlook

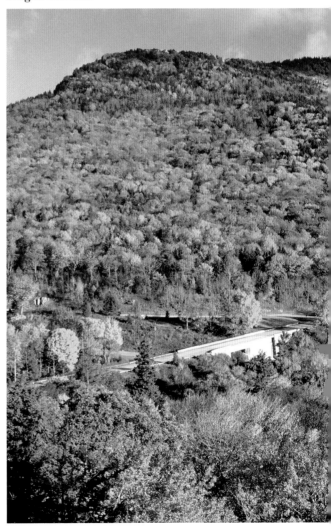

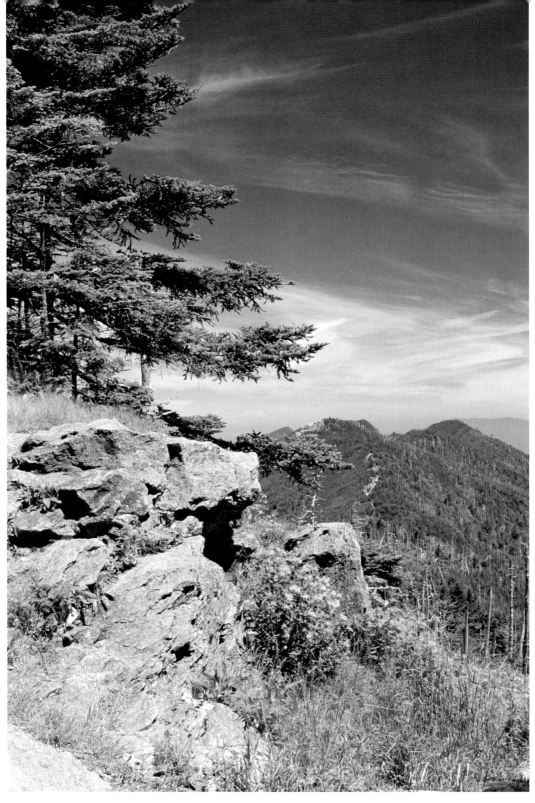

View from Mount Mitchell summit, near MP 355

VII. The Tallest Mountains in the East (Milepost 318 to Milepost 373)

General Description: Northeast of Asheville, the Great Craggy Mountains and the Black Mountains come together to form the highest mountain complex in the eastern United States. This amazing knot of mountains includes Mount Mitchell, at 6,684 feet the highest summit in the East. Although owned by the state, Mount Mitchell has long been an unofficial pearl in the Blue Ridge Parkway's string, its peak easily reached from a parkway spur road. The section of the Craggy-Black complex known as Craggy Gardens provides a large natural rhododendron garden with wide views;

Craggy Gardens

Where: The central mountains of North Carolina, north of the city of Asheville.

Noted for: The tallest mountains in the East, subarctic forests, wide views, waterfalls, heritage apples.

Watch for: After you pass NC 226A (MP 333.9), your next gasoline stop will not come until US 74 (MP 382.6), nearly 50 miles later. Verge-side parking is prohibited between MP 355.4 and MP 370.3, as the parkway passes through Asheville's watershed.

Facilities: The Museum of North Carolina Minerals (MP 331, on NC 226) has a visitor center. Crabtree Meadows (MP 339.5) has camping, picnicking, and a café. Mount Mitchell State Park (MP 355.3) has picnicking, tent camping, a visitor center, and a café. Craggy Gardens has a visitor center (MP 364.5) and picnicking (MP 367.6).

Sleeps and Eats: Food and lodging are available a short distance north on NC 226 (MP 331) at the small county seat of Spruce Pine, and again at NC 226A (MP 333.9) at Little Switzerland. At the southern end, the city of Asheville has every comfort and convenience you could imagine.

blooms peak in mid-June with some color lingering into mid-July.

There's one more important point about the Blue Ridge Parkway in this segment: it leaves the Blue Ridge. From the beginning of the parkway's creation, its planners intended it to link the Shenandoah and Great Smoky Mountains national parks, and it became the "Blue Ridge" Parkway only after several years of political wrangling about its route. The mountain

The Orchard at Altapass

crest known as the Blue Ridge doesn't come near the Smoky Mountains, but instead veers south to South Carolina and Georgia. In order to reach the Smokies, the parkway heads westward, away from the Blue Ridge, at MP 353.8.

Directions: Northern access is via US 221, which heads south to Marion and I-40. Southern access is from Weaverville, a northern suburb of Asheville; from US Bus 19 south of town center, take Reems Creek Road (SSR 1003) east for 4.5 miles to a right onto Ox Creek Road (SSR 2109), then 4.3 miles to the parkway. No major through highways intersect the parkway along this segment, but NC 226 at MP 331 leads north to services.

String of Pearls: The Orchard at Altapass, Milepost 328.4 (54)

In 1908 the Clinchfield Railroad planted this apple orchard in a loop of its railway as it climbed the crest of the Blue Ridge. Then, in the 1930s, the Blue Ridge Parkway was constructed to pass through the middle of the orchard—resulting in a mile of sweeping views over large apple trees seasonally heavy with fruit, one of the great sights of the roadway. The heritage apple trees, over a century old, went through a period of decline but are again healthy and beautiful, restored by their private owners, framing unimaginable views with bright red fruit in huge clusters. In season,

warm weekend afternoons ring to the sounds of local country musicians performing near the apple packinghouse. Behind the packinghouse is a monarch butterfly garden (the staff hand-raises monarchs in a special area of the packinghouse), an herb garden, and a spring wetland. There is also a small café, for when you're feeling peckish.

Open daily, Apr. to Nov. Free admission; weekend music also free. Call 888-765-9531, or visit www.altapassorchard.com.

Approaching the Black Mountains, Milepost 338 to Milepost 350

Between the Orchard at Altapass and MP 338, the parkway is pleasant but yields only occasionally remarkable views. Things pick up a bit as you pass MP 338 and (not coincidentally) begin to approach the 4,000-foot contour. Views on both sides of the mountain become more rugged and remote. At MP 339.1 you'll find a set of **classic Blue Ridge views (55)**—first a view north over side ridges, followed immediately by a classic edge-of-the-world view off the other side. If skies are overcast, the northeast-facing **Crabtree Falls (56)** is impressive, reached via a 2-mile path in Crabtree Meadows Campground (MP 339.5) with 600 feet of elevation drop and gain. But you really want sunshine on this section, for the stunning panoramic view westward to the **Black Mountains (57)** at MP 342.2. You can pick out

Winter view of Black Mountains, from Black Mountain Overlook, MP 342

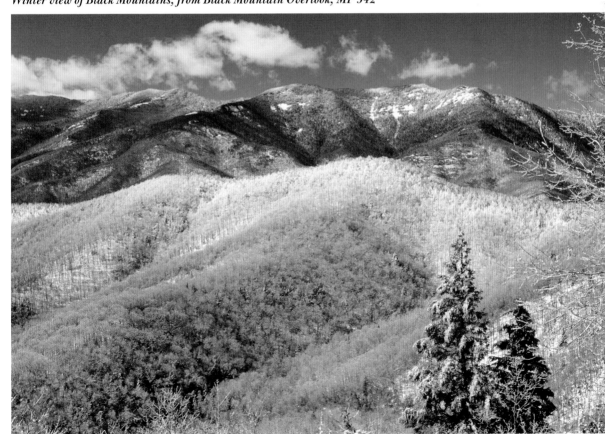

Mount Mitchell, the tallest peak east of the Rockies, by the observation tower on its peak.

String of Pearls: Mount Mitchell and the Black Mountains, Milepost 355.3

In the mid-19th century, New Englanders were incredulous to hear that Mount Mitchell, the tallest of the Blacks at 6,682 feet, was more than 400 feet taller than New Hampshire's impressive Mount Washington. By the end of that century, people knew that eight Black Mountain peaks topped Mount Washington, and that more than 11 miles of the range's 16-mile ridgeline had elevations above 6,000 feet.

There's something else remarkable about the Blacks—paved, mile-high highways parallel the top of this rugged and remote mountain range for a third of its distance, including 4.6 miles of the Blue Ridge Parkway. The 4.8-mile Mount Mitchell spur road climbs the Black Mountains crest from the parkway into the state park, finally reaching 6,500 feet (take that, Mount Washington!) at a parking lot 0.25 miles below Mount Mitchell. These roadways form a continuous corridor of views and trailheads, including the short, easy path to the Top of the East itself.

The 1,700-acre **Mount Mitchell State Park (58)**, at the end of the road, is the main attraction, stretching along the high ridgeline of the Black Mountains. The wide, easy path to the summit passes through forests and wildflower meadows to reach the peak in 0.25 miles. A newly constructed tower allows you to climb above the trees for a 360-degree view, with the entire eastern United States beneath your feet. For more information call 828-675-4611, or visit www.ncparks.gov/Visit/parks/momi/main.php.

String of Pearls: Craggy Gardens, Milepost 359.8 to Milepost 367.6

This is one of the most popular spots along the parkway, with good reason. It combines mile-high elevations, extraordinary wildflower meadows, stunning views, and great craggy cliffs. Appropriately, this range of mountains, running south from the Blacks to Asheville, is known as the Great Craggy Mountains.

This "pearl" is dispersed over a 7.8-mile length of parkway, from the start of the Crag-

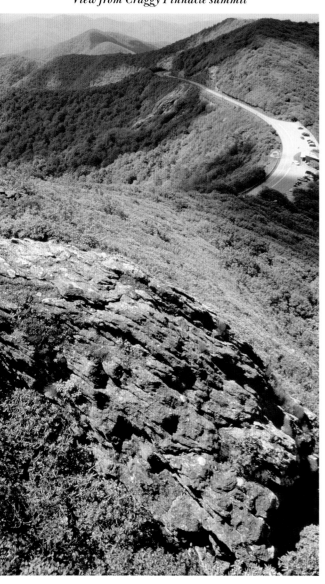

View from Craggy Pinnacle summit

gies at Balsam Gap (MP 359.8) to the Craggy Gardens Picnic Area (MP 367.6). Please note that verge parking is prohibited, as this section is within the Asheville watershed. Here are the photographic highlights:

• **Glassmine Falls Overlook (59)** (MP 361.2) gives a fine view across the Asheville watershed to this ribbon of water pouring over a cliff opposite, said to be 800 feet tall. As the watershed is closed to the public, this is as close as you can get to it; bring a long telephoto.

• **Craggy Dome Overlook (60)** (MP 364.1) is handsome enough with its stone walls and rhododendrons, but it's only the warm-up act. The main feature is Craggy Pinnacle Trail, heading 0.7 miles (and climbing 200 feet) to reach two stunning overlooks on this 5,892-foot peak. This is the best place to take a picture of the parkway looking down from above.

• **Craggy Gardens Visitor Center (61)** (MP 364.5), a small gift shop with a few exhibits, gives access to three photo opportunities. The most obvious one is right in front of you: a 180-degree westward panorama, where the ridges ripple in front of you like waves frozen in stone. The second photo op is the most famous, the renowned rhododendron meadows so beautifully set they have earned the name Craggy Gardens; the footpath to them, 0.2 miles long and climbing 100 feet, starts at the far end of the parking lot. The gardens are best viewed in mid-June when the bloom is at its height, but gives good views and wildflowers from May to October. The third opportunity is the least apparent. By now you have surely noticed how hard it is to get a really good photo of a parkway tunnel. To get one that will knock your socks off, park at the visitor center in the early morning and carefully walk through the tunnel just ahead. The morning light hits the tunnel entrance just right, and in mid-June the rhodo-

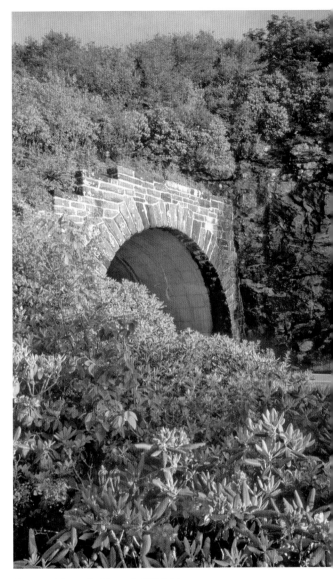

Craggy Pinnacle Tunnel, MP 364

dendrons on the downhill verge frame it perfectly.

• **Craggy Gardens Picnic Area (62)** (spur road at MP 367.6) is an attractive but unremarkable spot, but the 1.2-mile spur road that leads to it has some great late-summer wildflower displays along its grassy right-of-way.

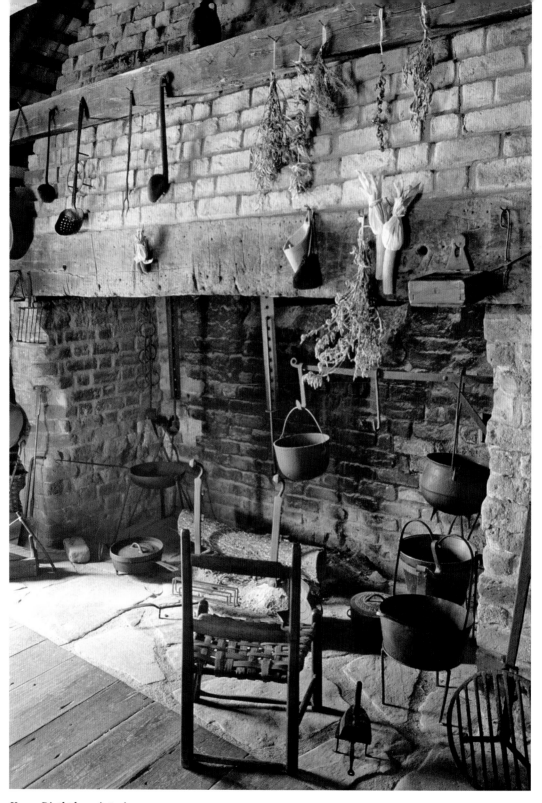

Vance Birthplace, interior

VIII. Asheville and the Pisgah Range (Milepost 373 to Milepost 412)

General Description: The parkway circles the small mountain city of Asheville to its east and south at elevations as low as 2,200 feet. After that, it swings westward to climb up Pisgah Ridge, topping out just shy of 5,000 feet in front of its final concessionaire, the Pisgah Inn. Much of the interest of this section lies in places immediately adjacent to the parkway, most especially the city of Asheville itself, with its 60 blocks of art deco downtown. Elsewhere along this stretch is the largest private home in North America; an antebellum log farm; the official state arboretum; and America's first forestry school, built of logs deep in the mountains.

Directions: Northern access is from Weaverville, an attractive small town just north of Asheville; from US Bus 19 south of Weaverville's town center, take Reems Creek Road (SSR 1003) east for 4.5 miles to a right onto Ox Creek Road (SSR 2109), then 4.3 miles to the parkway. Southern access is via US 276, which runs between Waynesville and Brevard. From Asheville, the parkway can be reached from four highways: US 70 east of town (MP 382.3); I-240 at its eastern end, as it becomes US 74A (MP 384.7); US 25 south of town and the best exit for the Biltmore Estate (MP 388.8), and NC 191 southwest of town and the best exit for the state arboretum (MP 393.6). Neither I-26 nor I-40 intersect the parkway. To reach the parkway from I-26, get off at Exit 2 and head south on NC 191. To reach the parkway from I-40, get off at Exit 53A and go east on US 74A.

Where: The central mountains of western North Carolina.

Noted for: The lively little city of Asheville, with galleries, shopping, museums, the state arboretum, and the largest private home in North America.

Watch for: No gasoline is available along the 60-mile stretch from NC 191 (MP 393.6) to US 23/74 (MP 443.1). Roads west of NC 191 are very poor and do not lead to services.

Facilities: The Folk Art Center (MP 382) has a visitor center. The Destination Center (MP 384.3) has a visitor center. Mount Pisgah (MP 408.5) has a visitor center, a café, a lodge, a picnic area, and a campground.

Sleeps and Eats: In Asheville, of course. If you want to treat yourself to some luxury, this is the place for it. For small-town charm try the B&Bs and restaurants in Weaverville, which retains its quaintness with seeming effortlessness and sits only a dozen miles off the parkway.

Off the Parkway: Vance Birthplace State Historic Site, Milepost 375.7, then 4.6 miles (63)

This log farmstead sits in a handsome valley a short distance off the parkway; follow Ox Creek Road (SSR 2109) for 4.3 miles to its end at Reems Creek Road (SSR 1003), then turn right. This is the birthplace of North Carolina's Confederate governor, Zebulon Vance—an anti-secessionist elected in 1862 by voters repelled by the Confederacy. The planked log

farmhouse is two stories, solid and handsome, and exudes modest prosperity; inside, it is furnished as it would appear in 1840. Around it cluster other farm buildings, forming an attractive group. On sunny days, try shooting from the western side of the site, placing the mountains in the background. On overcast days, shoot from the hilltops down into the log outbuildings in the glade below, using the trees to shut out the sky. When the site is closed (on Sunday and Monday), you still have good shooting from the roadside over the split-rail fence.

Open Tue. to Sat. Free admission. Visit www.nchistoricsites.org/vance/vance.htm.

Off the Parkway: Downtown Asheville via Town Mountain, Milepost 377.3, then 6.2 miles

This is a pleasant ridge-top drive dropping directly into the center of town following a 1920s-era scenic highway, NC 694, **Town Mountain Road (64)**; note the governor's western retreat on your right at 3.8 miles. The all-time best **view of downtown Asheville (65)** is off on your left at 5.6 miles, up Cogswood Road; you'll have to shoot over houses, however, and your luck will depend on the owners' landscaping preferences. It ends at US 70 on the eastern edge of downtown.

Asheville's amazing downtown developed during the 1920s land boom as a 60-block concentration of art deco eccentricity, now occupied by a glorious variety of shops, galleries, nightclubs, and restaurants. You will approach through the government district, dominated by the superb City Hall and large Pack Park, from which you can access **Pack Place and Asheville's Urban Trail (66)**. Here at the heart of the city you'll find a handsome square bordered by late-19th-century brickwork and sidewalk cafés, a giant early-20th-century marble library (now Pack Place, a museum), and a

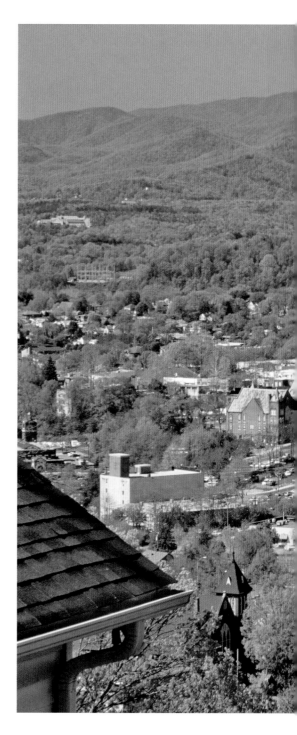

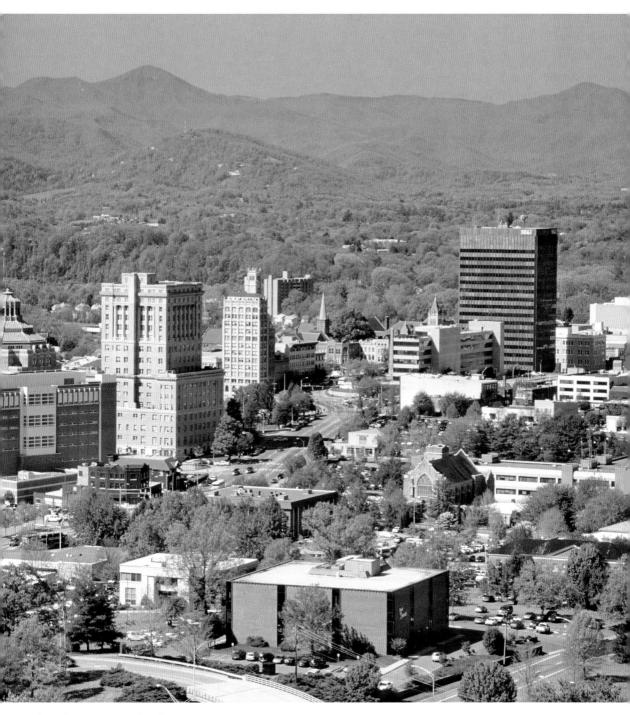

View of Downtown Asheville

large modernist office by I. M. Pei. Take in the rest of downtown by following the Urban Trail, a 1.7-mile walking tour whose main points are marked by 30 public sculptures (some of them pretty spectacular); you can get a brochure inside Pack Place. The best photographic subjects are the Grove Arcade (America's first indoor mall), and Lexington Avenue (Asheville's bohemian district). For more information on Asheville visit www.exploreasheville.com.

Asheville street sculpture

Off the Parkway: The Biltmore Estate, Milepost 388.8, then 3.5 miles (67)

Whether the largest, and most grandiose, private home in North America qualifies as a photographic site depends on whether you ever want to sell any image you take of it. You can't get in without a ticket, and the very act of purchasing a ticket binds you to a contract that prohibits all image sales. There are also large signs prohibiting "commercial" photography, and a holding company that claims to be able to use trademark laws to enforce the photography ban. If you set up a tripod, expect trouble. If you hand-hold an amateur-looking camera, and confine yourself to shooting exteriors, you won't be bothered.

Beyond being able to assure you that the property is truly wonderful and filled with wholly delightful photographic subjects, I can give you little guidance. I have never attempted to shoot there—or anywhere else that makes such draconian attempts to restrict and control photographers. I have, however, inspected it for my Explorer's Guide to this area, where you can read a detailed account of the entire estate.

Open daily 9 AM to 4 PM, Jan. through Mar.; daily 8:30 AM to 5 PM Apr. through Dec. Locations within the estate have different hours. Adult: $47 to $59; youth (10 to 17): $23.50 to $29.50. Varies by season and day of week; some days have timed entries. Call 800-624-1575, or visit www.biltmore.com.

North Carolina Arboretum, Milepost 393.6 (68)

Founded in 1992, this 426-acre arboretum has 36 acres of formal and informal gardens, greenhouses, educational programs, and miles of walking paths. The entrance drive, off the Blue Ridge Parkway at the NC 191 exit, is spectacular—beautifully landscaped in an unobtrusive style that blends in with the native

Path at Lake Powhatan, in the Bent Creek Forest

habitats, including a viaduct over a delicate stream environment. The handsome main building of stone and gray wood sits atop a series of contemporary formal gardens, and a separate series of native plant gardens. Behind the main building are the greenhouses, now the source of nearly all the seasonal and potted plants in the arboretum, and an active participant in the campaign to conserve rare and endangered native species. Paths stretch downhill through forests to Bent Creek, where there are more gardens, both existing and planned. The most interesting site for a May visit is the National Azalea Repository, containing all but two of the native American azalea species, on a shady spot that is ideal for overcast days. Gardens open daily 8 AM to 9 PM; buildings keep shorter hours. Free admission; $6 parking fee (waived on Tuesday). Call 828-665-2492, or visit www.ncarboretum.org.

Bent Creek Experimental Forest, Milepost 400.3 (69)

George W. Vanderbilt of Biltmore Estate fame created this tract in 1909 out of 70 separate small farms and wood lots, at least in part because they were in the middle of his view; his widow sold the land to the Pisgah National Forest for $5 an acre. Since then it has been given over to forestry studies. The result is a photographer's dream, a patchwork of all types and ages of hardwood forests covering the remnants of 19th-century settlements; its network of trails is (mainly) open to bicycles as well as walkers. Two places are particularly worth exploring for photography. **Lake Powhatan**

Milepost at the Little Pisgah Ridge Tunnel, MP 407

Recreation Area (70) features a classic Civilian Conservation Corp picnic area from the 1930s on an attractive small lake, while Hard Times Trail follows the former main road past ruins overgrown by forest. To explore Bent Creek Forest, look for the unmarked gravel forest road leaving the parkway at MP 400.3 (on your left as you head away from Asheville), then take gravel FS 429 right under the parkway. Lake Powhatan is 4.5 miles, then right; Hard Times Road Trailhead is at 4.6 miles. You can download a detailed map from the Bent Creek Web site. Call 828-667-5261, or visit www.srs.fs.fed.us/bentcreek/.

The Climb up Pisgah Ridge, Milepost 393 to Milepost 407

At MP 394.6 there is a fine **view of the Biltmore House (71)** against a mountain backdrop—as far as I know the only view of it available from a public right of way. As you travel away from Asheville the view is behind you; park on the roadside just beyond the view, and use a very long telephoto lens, such as a 400mm for a full 35mm frame.

Beyond this point are a series of views south over recently suburbanized valleys. The views improve dramatically after you cross a ridge at MP 399.3; now the national forest lands along the Mill River Valley are your view south, with a panorama just beyond Bent Creek Valley Overlook, MP 399.8. The views improve as you climb, off both sides of the mountain as you slab around the crest; there are particularly good views at **Hominy Valley Overlook (72)** (MP 404.2) and Mills River Valley Overlook (MP 404.5), but pay attention to roadside views as well, particularly at MP 405.1.

String of Pearls: Mount Pisgah, Milepost 408.5 (73)

The large **Mount Pisgah Recreation Area (74)** has picnicking, camping, a camp store, a good restaurant, and a nice lodge, all at an ele-

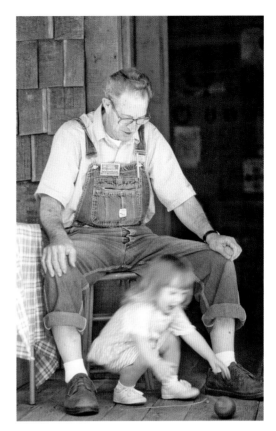

Child playing with a top made by toymaker Bob Miller at the Cradle of Forestry in America

vation around 5,000 feet. Its centerpiece is 5,721-foot-tall Mount Pisgah, reached by a 2.6-mile (round trip) trail that gains 700 feet in elevation. The path is a pleasant forest walk, fairly steep and generally busy; at its end is a large observation platform by an even larger TV tower, with a 360-degree view. Of special interest is the cable-driven rail car used by technicians to service the tower.

Views of Looking Glass Rock, Milepost 409 to Milepost 413 (75)

Looking Glass Rock is a giant granite dome, nearly treeless, rising 1,000 feet above the forests that completely surround it, and well over 1 mile long. As you drive away from the

Mount Pisgah area it dominates the wide views to your left, and remains a prominent landmark as far ahead as Devil's Courthouse (MP 422.4). Its slopes are popular with rock climbers, and a hiking trail sneaks up its southern slope for fine views and a close-up look at a large rocky bald.

Off the Parkway: Cradle of Forestry in America, Milepost 411.8, then 3.8 miles (76)

When George W. Vanderbilt founded Asheville's Biltmore Estate in the 1880s he had to import German foresters to manage his large holdings, and these in turn were forced to train their own forestry staff from scratch. Their training school is now preserved as the Cradle of Forestry in America, a beautiful and fascinating collection of historic log structures. The tour starts at the large modern museum, where historic and modern forestry practices are explained. Then a loop trail leads to the historic site, with a log schoolroom, store, and cabins. This is one of my favorite places for photography, both for the handsome historic buildings with their period furnishings, and for the craft demonstrations in front of the store. A second loop trail leads through a demonstration of historic forestry practices.

Run by the National Forest Service, the Cradle of Forestry is on US 276, 3.8 miles south of the parkway. Open 9 AM to 5 PM. Admission is $5 (free on Tuesday). Call 828-877-3130 or visit www.cradleofforestry.org.

Log cabins at the Cradle of Forestry in America

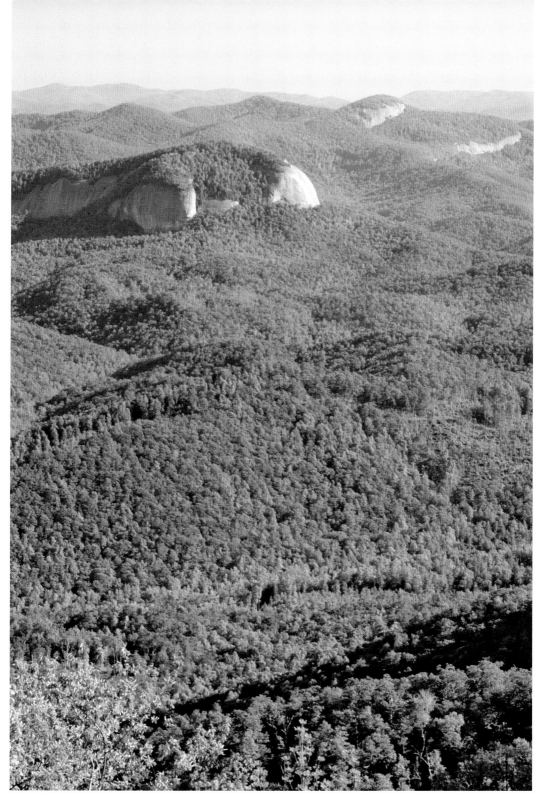

View of Looking Glass Rock from Pounding Mill Overlook, MP 413

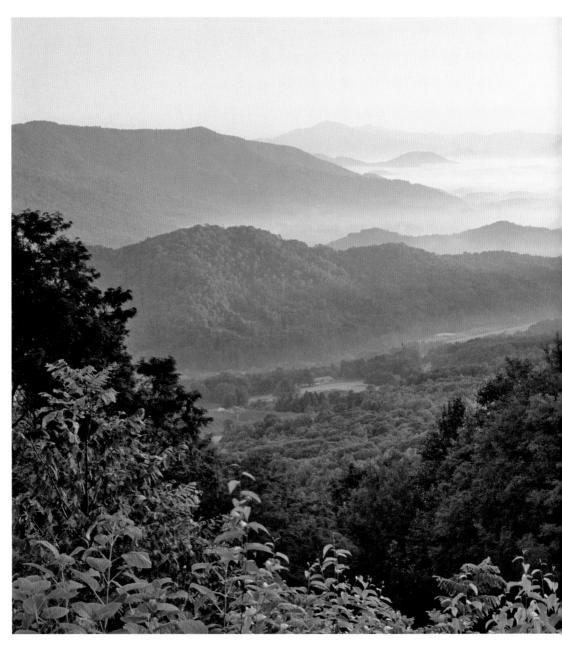

Sunrise view from Waynesville Overlook

IX. The Mile-High Crest
(Milepost 412 to Milepost 469)

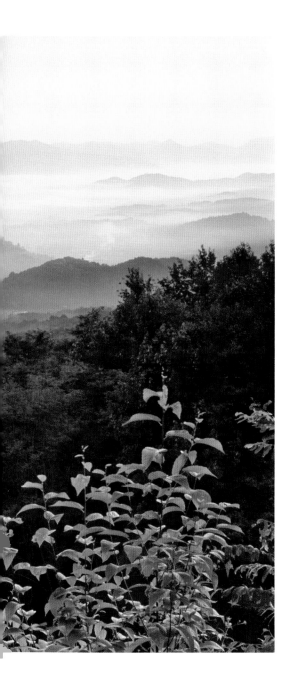

Where: The mountains of western Carolina, west of Asheville and south of the Great Smoky Mountains National Park.

Noted for: Incredible panoramic views, waterfalls, wildflower meadows, and a log-built farmstead.

Watch for: Because the parkway has now dipped south of its final destination, its north-south signs are backward—the signposted "north" is really due south, while the signposted "south" takes you north. Also, watch your gas gauge; you do not want to run low along this stretch. Gasoline is available at US 23/74 (MP 443.1).

Facilities: Waterrock Knob (MP 451.2) has a visitor center. Balsam Mountain (within the Great Smoky Mountains National Park, on the parkway's Heintooga Spur Road) has camping and picnicking. The Mountain Farm Museum at Oconaluftee (also within the national park, at the parkway's terminus) has a visitor center. All have restrooms.

Sleeps and Eats: The Balsam Mountain Inn, just west of the parkway off US 23/74 (MP 443.1), offers an exceptional dining and lodging experience in a historic railroad hotel. Cherokee, at the terminus of the parkway, has a full range of services.

General Description: The final section of the Blue Ridge Parkway moves along some of the highest and most dramatic mountains in the East, the Great Balsam Mountains. In this section the parkway not only passes above 6,000 feet, it spends more than 17 miles continuously above a mile in elevation. The roadway itself was largely built in the 1960s as a severely

straightened, wide-shouldered gash through one of North America's most sensitive environments, a unique high-altitude forest left over from the last Ice Age. The results, environmentally reprehensible though they may be, lay out the high forests and vistas in a way not to be found along any other eastern roadway.

Directions: Northern access is via US 276, which runs between Waynesville and Brevard.

A creek runs through Graveyard Fields

Southern access is via US 441 immediately north of Cherokee, just inside the entrance to the Great Smoky Mountains National Park. In between, you can reach the parkway at expressway-quality US 23/74, MP 443.1, and at US 19 near Maggie Valley (MP 455.7).

String of Pearls: Graveyard Fields, Milepost 418.8 (77)

This high-perched valley sits nearly a mile above sea level, flanked by seven 6,000-foot peaks. Once covered by huge old-growth forests—the "graveyard" refers to the grave-like mounds left by fallen giant trees of the old forest as they returned to the soil—it was devastated by clear-cutting and fires in the early 20th century and remains meadow-covered to this day. A lovely system of hiking trails, most starting at the Graveyard Fields Overlook, loops around the meadows, wildflower-carpeted in spring and summer, along the clear mountain river that cuts through its center, down to the roaring waterfall that marks its foot, and up to the tall, graceful waterfall that sits at its head.

The Devil's Courthouse, Milepost 422.4 (78)

This large, bare outcropping and cliff projects southward from the face of the Pisgah Range. The overlook gives a good view of it, with the best lighting in midafternoon. From there, a trail leads 0.3 miles (one way) to the top of the cliff, a climb of 280 feet. Up close it turns out to be a classic rocky bald, with all the features you'd expect: rounded, exposed granite with scattered moss beds, stunted trees, and a view to die for (literally, if you wander too far down the sloping stone).

Great Balsam Mountains, Milepost 424 to Milepost 431

This section of the parkway slabs along the western side of the Balsam crest, staying be-

tween 5,400 and 5,600 feet. With wide verges kept clear of saplings, the views are continuous and spectacular. Four places are particularly worthwhile. First, **Wolf Mountain Overlook (79)** (MP 424.8) gives a final panoramic view south; that ridgeline far in the background is the official Blue Ridge. Then, starting at MP 426.9, a mile-long stretch gives dramatic roadside views (with easy verge parking) down a 3,000-foot drop into a mountain valley and beyond to the Tuckasegee River, the Cowee Mountains, and the Nantahala Mountains. This might be the best spot for a sunset in the southern Appalachians; as the sun dips down into the lowest part of the deep valley it actually drops below the horizon to throw orange sidelights on the tall ridges to its right and left. Drive slowly through this section scouting for the best place to park and set up, then use **Caney Fork Overlook (80)** (MP 427.9) as your turnaround. At MP 430.7, Cowee Mountain Overlook gives a 270-degree view from a 5,960-foot promontory that thrusts westward from the parkway over the deep valleys of the Balsams. Finally, at MP 431, the Haywood-Jackson Overlook supplies the missing 90-degree view, eastward over the deep gorge of the West Fork to the mountaintop meadows of the Middle Prong and Shining Rock wilderness areas; the 6,030-foot peak of **Cold Mountain (81)**, featured in William Frazier's best-selling historical novel of that name, is in the far background.

The parkway passes along the Long Swag at MP 434

The Mile-High Crest's Northern End, Milepost 431 to Milepost 441

The remarkable scenery continues as you pass **Richland Balsam (82)**, the highest point on the parkway (elevation 6, 053 feet), but not particularly spectacular. There are stunning views west as you approach **Roy Taylor Overlook (83)** at MP 433.2; here a short stroll brings you to a fine overlook beautifully framed by twisted trees. From here the parkway traverses the west side of a long, narrow, meadow-covered ridge. This is the Long Swag, and although there are no overlooks, there is nothing to stop you from pulling safely onto the verge and walking through the meadow on your own, looking for wildflowers and views.

The parkway suddenly plunges off the ridgeline at Milepost 437, dropping nearly 2,000 feet in the next 6 miles. There are several good opportunities for photographs on the way down; be on the lookout for roadside spots from which to shoot the parkway as it traverses the mountainside ahead and below you. One of your best views is toward the bottom, at **Waynesville Overlook (84)** (MP 440.8). While it doesn't look like much, the view from the verge at its far end is over an orchard, then straight down a deep valley to the county seat of Waynesville. This is an excellent sunrise location; the mountains on your right will block the sun itself, while allowing color to flood into the valley below.

Off the Parkway: Balsam, MP 443.1, then 0.7 miles (85)

Once you've made that drop in elevation to Balsam Gap (MP 443.1), note that in the next 8 miles you'll regain it all, plus an extra 400 feet. (If you want to return to Asheville from here, you're only 30 miles away via the US 23/74 expressway, compared to 60 miles via the parkway.)

While this is a low point on the Balsam crest, at 3,314 feet it was once home to the highest passenger-railroad depot in the East (westward on US 23/74 a short distance, then right on Cabin Flats Road for 0.5 miles to Balsam). Naturally, it had a grand railroad hotel, the Balsam Mountain Inn, to take advantage of the cool air and beautiful scenery. Opened in 1908, the inn has never closed and is now a country bed & breakfast, carefully restored to duplicate the original experience. It's a great place to photograph, as well as offering first-rate dining and lodging. It's also worthwhile to poke around the shrunken village of Balsam, and to explore the historic old railroad (still an active freight line). For information on Balsam Mountain Inn: www.balsammountaininn.com.

String of Pearls: Waterrock Knob, Milepost 451.2 (86)

As you approach Milepost 451 you will reach the crest of Plott Balsam, here 5,720 feet high. A spur road to the left will take you 0.5 miles upward to the Waterrock Knob Visitor Center. This is a prime spot for views south over the Great Balsam Mountains. In the summer, rain clouds can slip through the low gap in front of you, a 2,500-foot deep nick in the rock. Mid-June, however, is the best time for viewing; the spur road and its overlooks become lined with rhododendrons and mountain laurels, and the remarkable elevation change lets you chase the seasonal blooms up one side of Waterrock, then down the other. A short, steep trail leads uphill 0.5 miles to the peak of Waterrock Knob, an exposed rocky bald ending in a cliff. Along the way, shots are plentiful as the paved path skirts ridge-top grasslands with stunted trees and rich wildflowers, climbs stone steps, and slips behind large outcrops. The views from the top are excellent, but not remarkably better than the view south from the parking lot.

Heintooga Spur Road, Milepost 458.2 (87)

This 8.9-mile pleasant side road follows the crest of the Great Balsam Mountains northward into the Great Smoky Mountains National Park. The drive is particularly nice in mid-June, when it is lined with rhododendrons, and late October, when it yields spectacular fall colors. It can also be a good place to spot deer and elk. At 1.4 miles on your left, **Mile-High Overlook (88)** furnishes a 180-degree panorama northwestward toward the crest of the Great Smoky Mountains, a fine location for a sunset. Then at 3.7 miles on your right, Black Camp Gap has been the site of a Masonic camp meeting every year since 1934; a historic Masonic monument sits on a knoll above a grassy field, and is worth the short walk. The pavement ends at Balsam Recreation Area, a

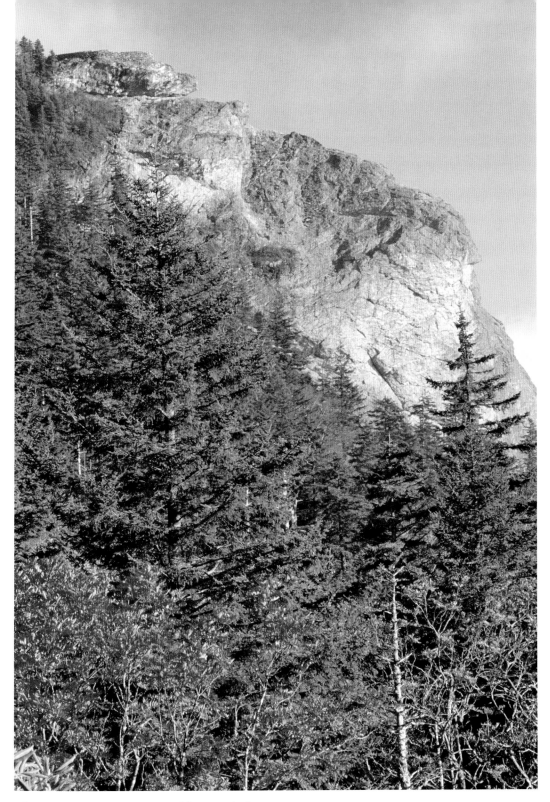

The Devil's Courthouse as viewed from overlook

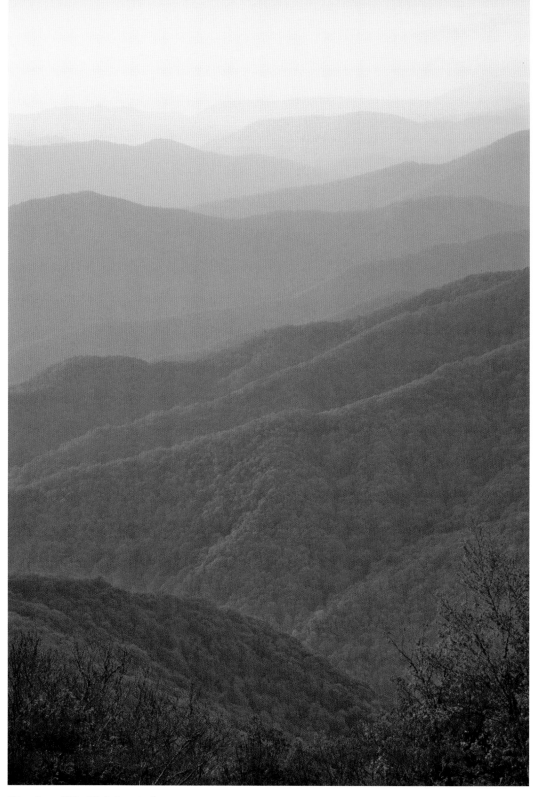

View from Mile-High Overlook

national park camp and picnic area at an elevation of 5,300 feet.

Balsam Recreation Area, 8.9 miles on the Heintooga Spur Road (89)

The Great Smoky Mountains National Park's highest, coolest, and smallest picnic area straggles along a ridgeline at the end of the pavement on Heintooga Spur Road. The first tables occupy what mountain folk call a balsam grove—a stand of tall spruce trees, spread wide apart with nearly no undergrowth. A short distance along the ridge you will find tables made of a single slab of quartzite, reminiscent of a druidic altar, and very nice for offering picnic sacrifices to the Ant God. If you want to do a setup of a happy family picnic outing, nothing says National Park like a megalithic slab.

Below the picnic area lies an old roadbed marked "Flat Creek Trail." This leads a short distance right to one of the park's best overlooks, Heintooga Overlook. Before this was a national park, locals would ride up the old lumber roads in their tin lizzies to enjoy the sunset views. Now the forests have grown back but the rangers carefully preserve the view, which encompasses the entire Smoky Mountain ridgeline. Every point you see is a mile high or more, and nearly every peak reaches 6,000 feet. The sunsets remain great.

Off the Parkway: Okonaluftee Mountain Farm Museum, Milepost 469.1 then 0.2 miles (90)

Located in the Great Smoky Mountains National Park on the Newfound Gap Road just right from the end of the parkway, the Oconaluftee Mountain Farm Museum is one of the most complete, and one of the most handsome, exhibits on mountain farm life anywhere in the southern Appalachians. Unlike sites in the more famous Cades Cove elsewhere in the park, the Mountain Farm Museum portrays a full-sized operating farm—flowers along the

Winter scene, Oconaluftee Mountain Farm Museum

porch, furniture in the house, corn in the field, chickens in the coop, and a horse in the barn.

The farmstead consists of log structures, all built around 1900, moved in from remote areas of the park and furnished in late-19th-century style with docents in period costume. The planked log cabin is surrounded by hand-split pickets and planted with beds of native flowers and vegetables. The cantilevered log barn, original to this site, anchors the other end. Inside are examples of late-19th-century farm equipment, a horse, several stray chickens from the nearby coop, and a cat. The horse is a friendly old creature and enjoys having his picture taken.

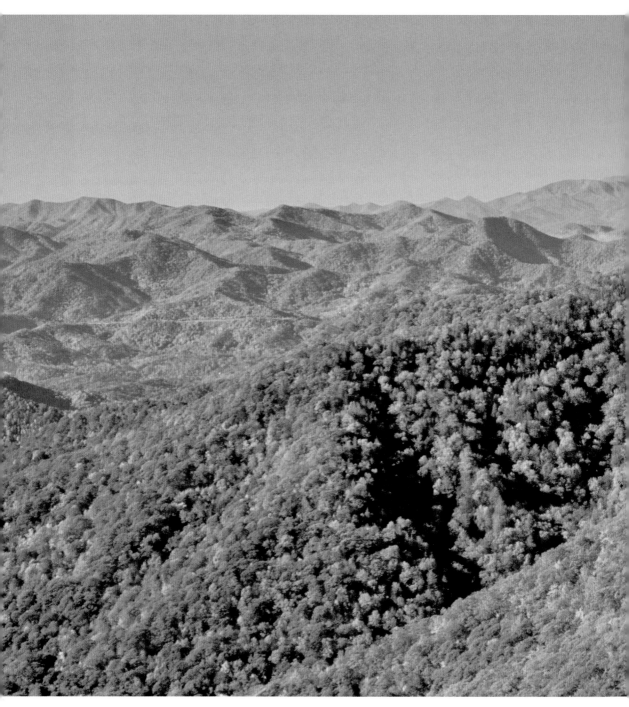

The parkway beneath Waterrock Knob, MP 450

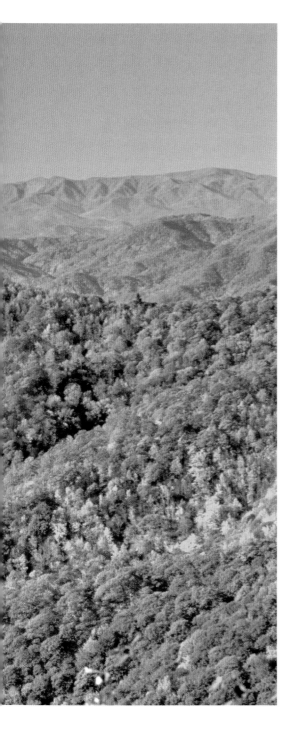

Favorites

Views
Humpback Rocks Trail, MP 6 (4)
Buena Vista Overlook, MP 45.7 (9)
Pine Tree Overlook, MP 95.2 (18)
Rocky Knob Recreation Area, MP 165.3 to MP 169 (28)
Doughton Park, MP 241.1 (40)
Grandfather Mountain Park, MP 305, then 1.1 mile (49)
Mount Mitchell State Park, MP 355.3 (58)
Craggy Gardens area from MP 361.2 to MP 364.5 (60 and 61)
Looking Glass Rock, MP 409 to MP 413 (75)
Great Balsam Mountains, MP 424 to MP 431 (79 to 85)
Waterrock Knob, MP 451.2 (86)
Heintooga Spur Road, MP 458.2 (87)

Log Cabins and Mills
Humpback Rocks Visitor Center, MP 5.8 (4)
Peaks of Otter, MP 83 to MP 87 (17)
Mabry Mill, MP 176.2 (31)

Vance Birthplace in winter

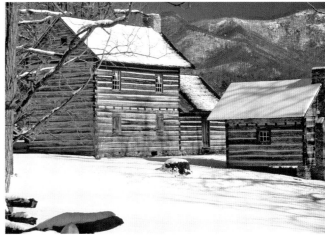

Brinegar Cabin at Doughton Park, MP 238.5 (41)

Vance Birthplace State Historic Site, MP 375.7, then 4.6 miles (63)

Oconaluftee Mountain Farm Museum, MP 469.1 then 0.2 miles (90)

Forests

St. Marys Wilderness, MP 22 to MP 27 (6)

Otter Creek, MP 55 to MP 63 (10)

Thunder Ridge Wilderness, MP 71 (16)

North Carolina State Arboretum, MP 393.6 (68)

Bent Creek Experimental Forest, MP 400.3 (69)

Waterfalls

Crabtree Falls, MP 27.2, then 6.2 miles (8)

Cascade Falls at E. B. Jeffress Park, MP 271.9 (43)

Linville Falls, MP 316.5 (53)

Graveyard Fields, MP 418.8 (77)

Rural Scenery

The Fields of Montebello, MP 24 to MP 31 (7)

A Long Countryside Drive, MP 136 to MP 176 (25 to 31)

Moses H. Cone Memorial Park, MP 294 (45)

The Orchard at Altapass, MP 328.4 (54)

Otter Lake

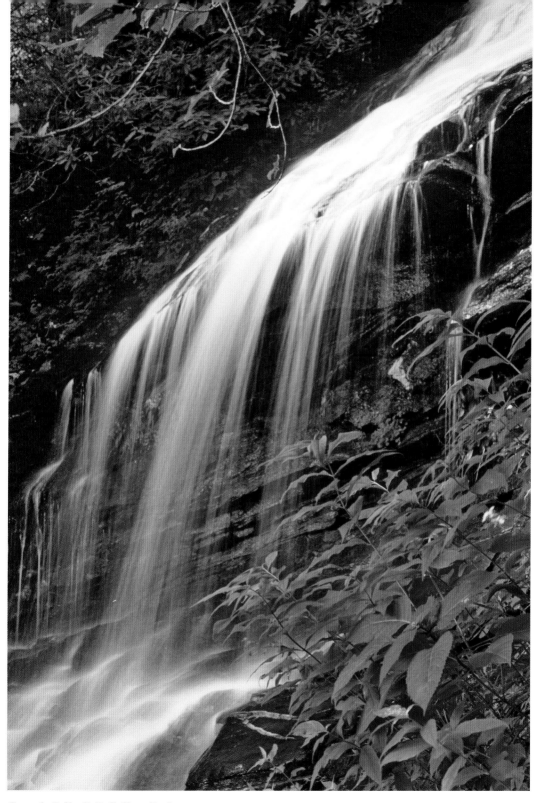

Cascade Falls, E. B. Jeffress Park

Otter Lake

Unusual Sights

Vineyards of Rockfish Valley, MP 0, then 4.1 miles (2)

The Appalachian Trail crossing the James River, MP 63.9, then 3.8 miles (12)

Illuminated Star on Mill Mountain, Roanoke, MP 120.5 (23)

Downtown Roanoke's City Market, MP 121.6, then 6.3 miles (24)

Stone Mountain State Park, MP 229.6, then 10.3 miles (39)

Holy Trinity Church, MP 258.6, then 0.5 miles (42)

Linn Cove Viaduct on Grandfather Mountain, MP 304.4 (48)

Pack Place and Asheville's Urban Trail, MP 377.3, then 6.2 miles (66)

Museums

James River Visitor Center, MP 63.6 (11)

Mill Mountain Zoological Park, MP 120.5 (23)

O. Winston Link Museum, Roanoke, MP 121.6, then 6.3 miles (24)

Grandfather Mountain Park zoo, MP 305, then 1.1 miles (49)

Biltmore Estate, MP 388.8, then 3.5 miles (67)

Cradle of Forestry in America, MP 411.8, then 3.8 miles (76)